SECRET BRISTOL

James MacVeigh

AMBERLEY

For the MacVeighs: Marenella, Frankie and Maria.

First published 2016

Amberley Publishing
The Hill, Stroud
Gloucestershire, GL5 4EP

www.amberley-books.com

Copyright © James MacVeigh, 2016

The right of James MacVeigh to be identified as the
Authors of this work has been asserted in accordance
with the Copyrights, Designs and Patents Act 1988.

ISBN 978 1 4456 5009 8 (print)
ISBN 978 1 4456 5010 4 (ebook)

British Library Cataloguing in Publication Data.
A catalogue record for this book is available from the
British Library.

Typesetting by Amberley Publishing.
Printed in Great Britain.

Contents

Introduction

Although I have lived in the city for decades, I am not a Bristolian born and bred. That may seem a disadvantage when writing a book like this, but if you have grown up in a place its odd nooks and crannies seem normal, whereas an outsider notices them. Much of Bristol's past has been distorted or forgotten. I have tried to rectify that.

1. Lost Times

'Start at the beginning,' that's the golden rule, so before we get to Bristol's pirates, the slave trade, riots and workhouses, and those odd places you may never have noticed, let us take a peek into prehistory. In the Paleolithic Period, from around 40,000 to 10,000 years ago, the Bristol Channel was not the expanse of turbulent water it is today but a flat, dry plain where rivers and streams ran into depressions in the ground to form lakes. It was bounded by higher areas to the north and south that are now South Wales, Somerset and Devon. It was during this long stretch of time that early man evolved fully into the *Homo sapiens* we are today, living in small hunter-gatherer bands and using primitive stone tools as well as implements fashioned from wood and bone. Fertile soil in the area gave these early people plentiful clothing and food, at least in summer. The coast at that time was far out to the west, and some communities may have trekked there for the winter months to hunt marine animals and fish, and eventually settled. As the planet warmed and glaciers melted in the Mesolithic Period, sea levels rose and these coastal communities were forced onto higher ground. Archaeologists believe the Bristol

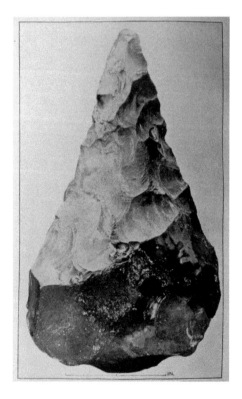

A Stone Age tool.

Channel may have been created by a tsunami, so some probably drowned. Lundy Island was then the highest point of a peninsula jutting into the sea, used as a vantage point from which by our distant ancestors looked for areas of edible plants as well as game. Exactly when these early people moved into what is now Bristol, a flat plain between the rivers Avon and Frome, is not known but it was certainly during this period. The place was ideal since it was bounded by water on two sides, which gave some protection against rival bands. We always imagine Stone Age man hunting mammoths and they did, but the animals they most commonly stalked were equines, dog-sized, prehistoric horses that may have evolved into modern ponies. Hares, hyenas and woolly rhino were hunted, as were the red deer whose descendants still roam Exmoor. The earliest geological deposits are the plateau gravels visible at Failand Ridge, which runs all the way to Clifton. Red sandstone eventually covered this, and many millennia later this would give names to the Bristol areas of Redland, Redfield and Redcliffe. Later still, the sandstone was overlaid by limestone, which is still excavated at Flax Bourton. There must have been settlements in Bristol during the Bronze Age (3000–2000 BC), as weapons made from this metal have been found nearby, including a dagger at Avonmouth docks. A young man from the Bronze Age whose skeleton was unearthed at Tormarton who'd had his skull smashed in.

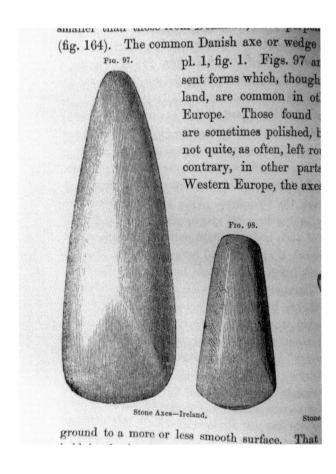

Stone Age axe head.

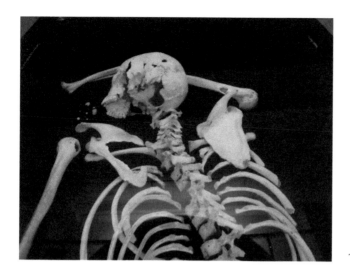

The Tormarton skeleton.

Concealed behind the cosy Druids Arms pub in the sleepy village of Stanton Drew there is the third largest collection of standing stones in England. Surpassed only by those at Avebury and Stonehenge, they receive little attention because they are so out of the way. The Great Circle is 113 metres in diameter and formed by twenty-six standing stones, or megaliths, with four more apparently missing, and there are two smaller circles nearby. The stones are known locally as the Wedding Guests. Myth has it that, long ago, a wedding party was held at the site one Saturday evening, and a fiddler hired. Drink was taken, but as midnight approached the musician stopped playing, to avoid working on the Sabbath. The guests complained and a new fiddler appeared and began to play. Faster and faster the wedding guests whirled to his music, unable to stop, and when dawn broke they were turned to stone. The second fiddler was, of course, the Devil.

The Druids Arms.

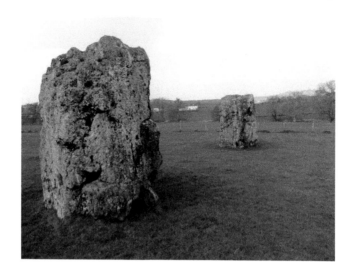

Megaliths at Stanton Drew.

By the Iron Age, Bristol had been permanently settled. The population was sparse and covered a large area. The new inhabitants were members of a tribe called the Dubunni, whose sphere of influence extended from Worcestershire to North Somerset, encompassing Gloucestershire and parts of Wiltshire and Oxfordshire. Remains of their prestigious hill forts, circular wooden palisades surrounded by high banks and deep, wide ditches to facilitate defence, were found at Clifton, Blaise Castle and Kings Weston. Significantly, the latter two sites were built on by the Romans, who often demonstrated their supremacy to local populations by taking over existing centres of power. At nearby Hallen, then a winter wetland, there lived a small, semi-nomadic band of summer inhabitants, the remains of the posts that supported their roundhouses were discovered in the 1990s along with a stone hearth. The bones these early people left behind indicate that hunter-gathering had given way to agriculture, as they had grazing animals with them. There were more Iron Age settlements in Henbury and Filwood.

The ending of the prehistoric period in Britain came with the arrival of the Romans with their advanced weaponry and military prowess, and their ability to read, write and record the world around them. As every schoolchild should know, they first set foot in Britain in 55 BC, but they did not stay for long, soon returning to their French colony of Gaul. Decades passed before they returned in force, and this time their aim was conquest. Although the ancient Britons put up sporadic resistance, including battles to the north of Bristol, their defeat was inevitable. Stiffer resistance in Scotland led to the Romans building their 73-mile-long Hadrian's Wall, on the orders of the emperor of that name. The Welsh also resisted, so forts were built at strategic spots to control them. In order to service these the Romans built a port settlement at Abona, now Sea Mills, and a road connecting it to *Aquae Sulis*, as they called Bath. They did not found the city of Bristol nor extensively inhabit what was then still a rural area, but Roman villas and farms were dotted here and there. Perhaps the grandest of these was the villa at Kings Weston, discovered in 1947 as the Lawrence Weston housing estate was being built. Unfortunately, the construction of Long Cross Road, which revealed this archaeological treasure, also

Roman villa at Long Cross.

destroyed the largest part of it, which now lies beneath the roadway. Some of the villa's mosaic floors and a hypocaust, the Roman system of underfloor central heating, can still be seen intact, and when the site was excavated it yielded finds of Roman coins, jewellery, iron tools and pottery. Another villa was unearthed at Brislington in 1899, during the building of Winchester Road. Dating from around AD 270–300, it formed the hub of a larger estate and stood until AD 367 when it was destroyed in a fire believed to have been set during an incursion by pirates from Ireland. The Roman settlement, at what is now Blaise Castle, with a temple on the hilltop built over the remains of an Iron Age fort, dates from the fourth century.

The ensuing centuries are known as the Dark Ages because few people had the ability to read or write, and little was recorded. It was only among the monastic communities, which were beginning to be set up as wandering monks spread Christianity through Europe, that there was any literacy, and that was in Latin and incomprehensible to lay people. Although evidence of life at the time is sparse there are signs that Bristol was already a functioning port, but one remote from civilisation. Once the Roman Empire had imploded and its armies withdrawn, the ancient Britons' power was usurped by the incoming Saxons and the area was absorbed into their kingdom of Hwicce. The first written evidence of Bristol's existence was a mention of Henbury in 692, as an episcopal possession of the newly established Christian community at Westbury. The name Bristol derives from the

Anglo-Saxon or Old English name Brycgstowe, with Bricg (brig) meaning a bridge and stowe meaning a place, as in Stow-in-the-Wold. Eventually the name became Brigstow and over the ensuing centuries the letter 'g' was worn away to leave Bristowe or Bristow. Any reader wondering how the letter 'l' became tacked onto the end of name to make 'Bristol' need only listen to working-class Bristolians: to this day they often add an 'l' to words ending with a vowel, so that 'banana' becomes 'bananal', 'saw' becomes 'sawl', and so on.

The first king of all England was Alfred the Great, so-called because he ended the Viking attacks that had happened over previous centuries, reputedly defeating them in ships that were built on the River Axe in Somerset. A wise ruler, Alfred urged the coastal towns of England to build fortifications so that they could better repulse attacks, and because of its natural defences between the Avon and Frome rivers it seems that Brycgstow responded, and grew in size and importance as a result. By the early eleventh century it had its own mint, and a silver coin from the reign of Æthelred the Unready (978–1016) is displayed at the royal collection in Stockholm, minted by a man named Aelfwerd in 'Bricgstowe'.

After the Norman Conquest in 1066, Bristol put up no resistance but apparently accepted the appearance of rulers who were foreign in customs, dress and language. Having had himself crowned king in London, William ordered that a castle be built in Bristol, both to protect its vulnerable eastern approaches and to impress the locals with a show of Norman power. A motte-and-bailey castle was built on the edge of the

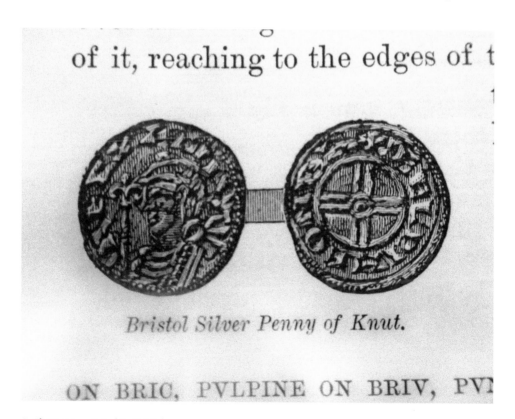

A silver coin minted in Bristol.

town, that is, a castle with a keep built on a man-made mound, or motte, enclosed by walls. The first castle was constructed of timber and had earthen walls, but this was later strengthened by Robert Fitzhamon, known as Robert of Gloucester, bastard son of Henry I, with stone walls more than twenty feet thick being built, and in 1106 he had St Peter's Church built in the castle environs. The town of Bristol had already surrounded itself with a gated stone wall for the protection of its citizens, and these were to stand for centuries, though little of them remains today. Bristol Castle was hugely impressive, being only surpassed by the Tower of London, and after it was built Bristol grew larger and more important. From the twelfth century, too, a market began to grow outside the city walls and, as its prime purpose was to provision the castle, it became Bristol's first suburb. As other markets appeared over the centuries this area became known as Old Market, and when the town walls were extended to join with those of the castle, encompassing the vast edifice as though holding it in an embrace, a ditch was dug around Old Market that could be crossed at Lawford's Gate. Bristol was given its first Royal Charter in 1155, succeeded in 1172. During the ensuing centuries a medieval town grew in the castle's shadow, with streets like Cock & Bottle Lane becoming famous throughout the land. Sadly, the castle itself was demolished after 1665 on the orders of Oliver Cromwell, because Royalists had briefly made Bristol one of their strongholds during the English Civil War, and all that remains of it today are some of its foundation stones. St Peter's Church and the surrounding medieval streets stood until 1940, when they were destroyed in the Blitz.

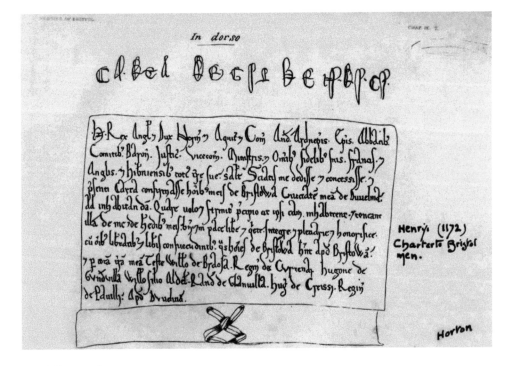

Royal Charter of 1172.

Philippa's stone on Redland Green.

DID YOU KNOW THAT...?

Archaeologists believe that the large stones on Redland Green were placed there in prehistoric times. One stone is now a memorial to schoolgirl Philippa Harradine, who was tragically hit by a car and killed at the age of fifteen. Rest in Peace, Philippa.

2. Trading Places

It is an uncomfortable truth, but one of the earliest cargoes exported from the port of Bristol were human beings. Slaves. We are not talking here about the trafficking in African people that the words 'slave trade' first conjure in the mind, but a far earlier version of this inhuman commerce. The trade was an accepted practice long before the arrival of the Romans in 55 BC, and they carried it on in their new colony of Britannia as they did everywhere in their empire. The manpower needed to build such early achievements of engineering as Roman roads, fortifications and villas was obtained by enslaving Britons. When Pope Gregory the Great (AD 540–604) saw flaxen-haired children being sold at a slave market in Rome, he asked where they had come from and was told, England. 'They are not Angles,' he replied, 'but angels.' The Romans did not have a monopoly on slavery. Ireland's patron saint, Patrick, a Romano-Briton, was captured by Irish pirates at the age of sixteen, taken to their country and forced to work as a shepherd. After six years he escaped and returned to Britain, but he returned to Ireland around AD 450 and made his home there. The trade in slaves carried through the port of Bristol continued for centuries after the Romans had departed, with men, women and children being kidnapped, mostly from Wales but sometimes after incursions into the north of England. Most were sold to the Viking settlement in Dublin, after which they could be exported anywhere in the known world. This cruel trade continued until the arrival of the Normans in Bristol in 1068.

Most of our early trade was not so brutal. One of the earliest indications of commerce comes in fragments of pottery found in the area of the Bristol Channel that had their origins in the Mediterranean, some dating from the fifth and sixth centuries. These artefacts have turned up in quantities that suggest commercial links, but it is possible that they were brought in over a long period by the few individuals who travelled in those times, usually Christian monks. Bristol's geographical position made it a natural trading port, firstly with Wales, Somerset, Devon and Ireland, later with more far-flung countries, especially France, Spain and Portugal, and even Iceland. Wool had been produced in England, including in and around the original 20-acre settlement of Bristol, ever since sheep had been domesticated. First it was simply plucked from the animals in summer, but combs were used later. Early Viking combs made from reindeer horn have been found in England but when this simple tool first appeared in Bristol is not known. In the early Middle Ages wool was a lucrative source of income. Woven, it was produced mainly for domestic use, but expert weavers in France and Holland paid good prices for English wool and the raw material exported from Bristol often found its way to them. Leather was also exported, and in return huge quantities of wine were brought in from southern Europe, as was woad which was used in dyeing. At the time of the Norman Conquest Bristol's population was around 4,000, large by the standards of the Middle Ages. In 1154 Henry II

was crowned king, and because he was also king of south-west France, links were forged with the region of Gascony that still survive, with Bordeaux and Bristol now twin cities.

There were good reasons for building Bristol Bridge where it is. Erecting a bridge across the mouth of the River Avon would have posed insurmountable problems for early engineers, but as the river is tidal ships could traverse its 7 miles to the town, tie up, and lie beached in the mud to be unloaded when the tide turned. By the thirteenth century, civil engineering was advanced. The Saxon bridge that gave Bristol its name had been built of wood, but in the 1240s it was replaced by a more durable stone structure that carried houses, shops and even a church. As trade increased, more harbour space was needed. The River Frome had always joined the Avon like the crook of an elbow below Bristol Bridge, thus forming a vital part of the town's defences, but in 1239 the decision had been made to carry it along for a further half mile to join the Avon lower down. This huge enterprise was finished in 1247 and was so effective that the new layout stayed in place for over 500 years.

From the reign of Edward I (1272–1307) onwards, English kings saw that there was money in wool and began to tax it. The Hundred Years War (actually 116 years, 1337–1453) was fought partly to protect the wool trade with Flanders. As the conflict progressed Flemish weavers fled their country and some settled in Bristol, where there was a growing demand for their skills but also resentment from local weavers. In earlier days, the trade had involved exporting wool to Flanders and reimporting it as woven cloth, but as England industrialised the cloth became increasingly woven at home. The profits to be made in exporting the finished product were huge but the sea journeys were dangerous because of pirates and bad weather, and would eventually give rise to the Society of Merchant Venturers who controlled the port of Bristol for centuries. The wool trade continued to grow, and one sign of its importance in the life of Bristol in the Middle Ages is the fact that the industry's guild had a Weavers' Chapel within Temple Church. A couple of years before his death in 1147 the Norman knight, Robert of Gloucester,

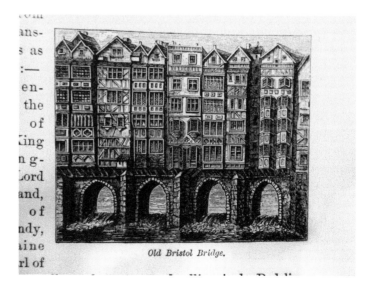

Old Bristol Bridge.

Old Bristol Bridge.

The Fleece.

DID YOU KNOW THAT...?

The Fleece music venue in St Thomas Street was originally a Wool Hall built in 1830. The wool industry flourished in Bristol from the eleventh century, with sheep freely roaming the streets. Fullers softened the wool by treading it in tubs of stale urine, and because of the smell they were forced to live outside the city walls in Redcliffe.

had given a marshy area south of the River Avon to the Knights Templar. They were the soldier-monks, formed during the Crusades, who took upon themselves the task of protecting the Church of the Holy Sepulchre in Jerusalem, thought to be the birthplace of Jesus Christ, guarding pilgrims on their dangerous journeys to visit the holy place. Their marshy area included Temple Meads, which still bears their name, and the knights built an oval church called Holy Cross on the spot close to what is now Victoria Street. They were a significant force for 200 years, but Pope Clement V considered them too powerful and ordered their dissolution, which was enforced in England by Edward II. Some Templars were imprisoned in Bristol Castle and eventually killed there, but others may have escaped. Their lands were confiscated and given to the Knights of St John, whose name lives on as Canons Marsh. They drained the marsh and built the present church there, calling it Temple Church in memory of its founders. Work on its tower started in 1390, but had to be stopped when it began to lean to one side. The joke that circulated at the time was that it had slipped out of true because it was built on a foundation of woolsacks – a dig at the industry that funded it. Engineering work was later carried out, building resumed in 1459, the tower grew upwards at a straighter angle and the join between the two can still be seen. Sadly, the church received a direct hit during the Blitz

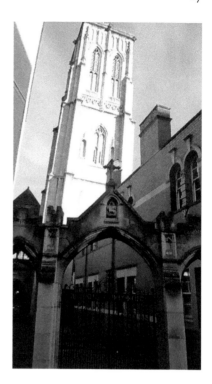

Temple Church.

along with much of medieval Bristol, but the building remains of interest as the Leaning Tower of Bristol.

The wool trade continued to flourish when the Black Death was brought to England by a Bristol seaman in June 1348, after his ship docked at Weymouth on a return voyage from Gascony. The plague spread like wildfire, killed around half of England's population and brought Bristol, then England's second city, to its knees. It was to stunt population growth for the next two centuries, and makes it easy to underestimate the trade carried out in Bristol during that period. As well as the staple of wool, leather, and livestock, locally made rope and sailcloth were exported, as was lead. Fishermen accustomed to venturing to Ireland travelled further afield, bringing fish home from Iceland and beginning to trade with that country. Already large, the port of Bristol's commerce became huge by the standards of the Middle Ages, when it was surpassed only by London. The merchant and ship owner William Canynges (c. 1399–1474) is a case in point. A wool merchant like his father and grandfather before him, even after seven centuries this remarkable man's name lives on in street names and elsewhere. At the height of his career he owned 100 ships and employed 800 seamen as well as 100 carpenters, masons and other workmen, the last of these during his rebuilding of St Mary Redcliffe. As the port grew in size and importance, so did the city of Bristol. In 1373 the neighbouring boroughs of Redcliffe and Bedminster were absorbed into it after long being considered suburbs, although Bedminster had been an established town when Bristol itself was little more than a settlement around the bridge, and there may have been an Iron Age village in the area now covered by East and West Streets. The Romans had an estate there, and by borrowing the key from Blaise

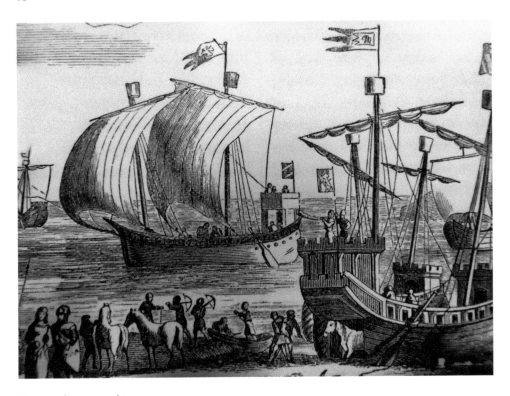

Thirteenth-century ships.

Castle Museum, you can see mosaics taken from it and preserved at Long Cross. There were mills on the Malago River whose clean waters could be dammed to make them fast flowing, and it was the site of early Christian baptisms. The ancient word for baptism, Beydd, may be the origin of Bedminster's name, while the name Malago also has its roots in pre-Roman Britain, since *melis* meant mill and *agos* was place in the Celtic language of the ancient Britons. Bristol's wool industry slowly declined from the late Middle Ages, but the trade continued in the city, gaining its raw material throughout the West Country.

In old Bristol, the wooden ships would sail into the port at high tide, tie up, and wait for the tide to go out, when they would be unloaded as they lay beached in the mud. Since many cargoes were heavy, this placed such a strain on the ships' timbers that they were in danger of falling apart, and there is no doubt that many must have done so. As a result, the ships built locally were made of only the finest timber constructed to the highest quality, and this is the origin of the phrase, 'All ship-shape and Bristol fashion.' That ships were built in the port is not in doubt, but as with everything else in the Dark Ages and even medieval times, little trace of them remains. However, during a 1970s refurbishment of Nos 7–8 King Street, built in 1665, it was discovered that the oak studs and the braces of the building were recycled ships' timbers. When the explorer Giovanni Caboto (1450–1499) moved to Bristol from Venice he became known as John Cabot, and was encouraged by Henry VII to seek support for his scheme to discover a westerly shortcut to Asia. Bristolian seamen may have made landfall in America in earlier

times, for there was a legend in the city that a great island lay far out in the Atlantic. After 300 years controlling the port's trade, the Society of Merchant Venturers were wily, daring entrepreneurs, and so ruthless that they resembled the pirates who always troubled the city. Many were fabulously rich, and ready to speculate with an eye on the main chance. Always eager to develop new areas of trade, they bought a ship for Cabot, a caravel called the *Matthew* which evidence suggests was built in Redcliffe. In 1497, John Cabot landed on an island off the coast of North America, named his discovery New Found Land, and claimed it for the English crown. On his return, the ancient road close to Brode Mede (Broadmead), then called Earls Mede Streete, was given its present name, Newfoundland Road, in his honour. Cabot was given a pension of £20 by the king and set sail for North America again the following year, but the trip was fraught with problems. His ship encountered icebergs and extreme cold, and when its crew refused to go any further north, Cabot sailed to Greenland and then turned south. There is no record of him returning to Bristol and he may have perished at sea, but as his pension continued to be drawn until 1499 it is generally accepted that his death happened in that year. Also in 1499, a Bristol merchant, William Weston, followed Cabot's route and became the first Englishman to lead an expedition to America. In 1552, Edward VI gave the Merchant Venturers a Royal Charter that granted them a monopoly on Bristol's sea trade. By that time the port's fishermen, who had always sailed to Iceland, were making routine voyages to the even richer fishing grounds of Nova Scotia. In 1994, a replica *Matthew* was started

Cabot's whalebone in St Mary Redcliffe.

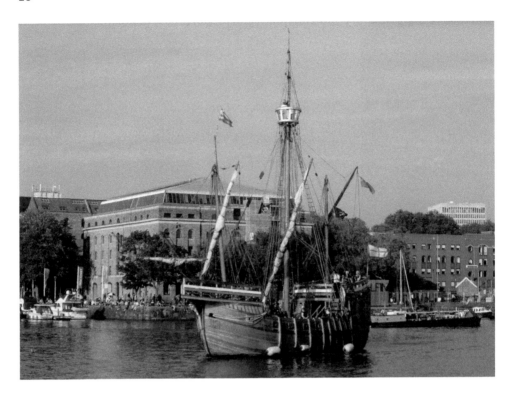

The *Matthew*.

in Bristol. In 1996 she was launched from Redcliffe Wharf and began her first trip in the wake of the intrepid John Cabot, whose name is found throughout Bristol, most recently in the shopping centre at Cabot Circus.

Ships continued to be built in Bristol during the ensuing centuries, but the business of unloading beached vessels had an adverse effect, and in the late 1700s trade began to decline as ships diverted to Liverpool. In 1802 William Jessop, a waterways engineer, came up with his scheme for a Floating Harbour. (It is not the harbour itself that floats but the ships that enter it). The Avon was dammed at Hotwells and again near Temple Meads, trapping the water from the Frome and the Avon between these points, while Netham Weir controlled the level of water in the harbour, letting the excess spill into a new Feeder Canal to be directed back to the tidal part of the Avon. Finally, Cumberland Basin was built with a lock at each end to accommodate large vessels, while smaller boats floated along the still tidal New Cut to the Bathurst Basin by the Ostrich pub. Work on the Floating Harbour finished in 1809, allowing shipbuilding to continue at Wapping Wharf.

In 1772 James Hilhouse had founded a shipbuilding company after inheriting his father's wealth, some of which had come from the legalised piracy known as privateering. The company made naval frigates and merchant ships until the beginning of the nineteenth century, and built the *Charlotte and Hope*, Bristol's first steam-powered ship, in 1814. In 1820 the firm built the dry dock at its Albion shipyard which had a capacity of 350 tons, still a familiar sight to travellers along Hotwells Road. The Hilhouse company

became somewhat eclipsed in 1838 when William Patterson built Brunel's revolutionary wooden-hulled paddle steamer SS *Great Western,* and even more in July the following year when construction started on SS *Great Britain,* the first iron ship to have a screw propeller. Hilhouse had taken on a young shipwright called Charles Hill who eventually became his partner, and in 1845 Hill took over the company which became Charles Hill & Sons, who carried on producing small ships until 1977. In 1980 the yard was taken over by David Abels and produced ships including tugboats, car ferries, patrol boats and survey vessels. Abels Shipbuilding, still a going concern, also makes architectural sculptures, and manufactured the wonderful Pero's bridge, named after a slave, Pero Jones, who was brought to Bristol in 1784 as the 'property' of Bristol merchant John Pinney, and lived in the Georgian House until his death thirty-two years later.

Before 1831, the engineer Isambard Kingdom Brunel drew up a design for a suspension bridge spanning the Avon Gorge which came to nothing, but after his death in 1859 his plans were revised, and the structure was finally built in 1864. After thirty years as a passenger ship, his SS *Great Britain* was converted to carry cargoes and made countless transatlantic voyages carrying coal to the Americas. In 1886 she was damaged in a storm off Cape Horn and limped into port in the Falkland Islands, where she lay rusting until 1970 when a naval architect, Ewan Corlett, had her put onto a huge pontoon and floated her back home. She was towed triumphantly into Bristol pulled by the tug *John King,* built by Charles Hill in 1935. Extensively refurbished, SS *Great Britain* now rests happily in the Great Western Dockyard with a new life as an award-winning museum.

Charles Hill shipbuilding

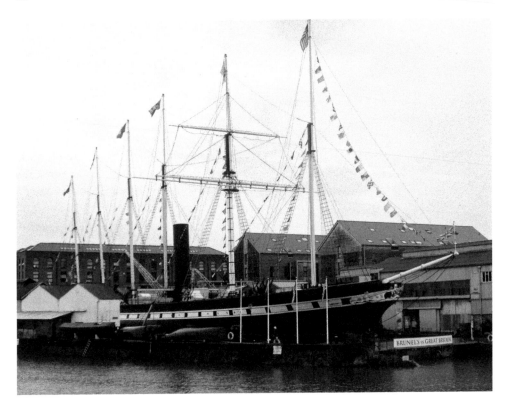

The SS *Great Britain.*

3. From Horse Trams to Helicopters

Entrepreneur George White (1854–1916) was born in Kingsdown, Bristol, the son of a humble painter and decorator. He started up the Bristol Tramways Co. in 1875, beginning with a service from Upper Maudlin Street to Blackboy Hill, and he later added a service to Clifton. The terminus for these early trams still stands in Perry Road. Now a microbrewery bar/restaurant, it remains easy to imagine horse-drawn vehicles driving out from beneath its arch. White was soon operating horse trams throughout the UK and Ireland, and when he introduced electric trams in 1895 Bristol was the first city to have them. Bristol Tramways kept its name after running its first motor bus from the centre to Clifton in 1906, but later became the Bristol Omnibus Co. In 1908 White, unsatisfied with the quality of the early buses he had bought, set up the Bristol buses manufacturing company in Brislington, and for the next seventy-five years they were not only used in the city, but also exported around the world. Today they are seen as iconic in places as far apart as India, Africa and Canada, and preserved Bristol buses are still being exported to collectors in other countries. George White also started the Bristol Aeroplane Co. and transferred its Bristol scroll logo to the buses, making their colours blue and white in remembrance of the fighter planes made at Brislington during the First World War. The trams did not begin to be wound down until the late 1930s, and only stopped when their generating centre was destroyed in the Blitz. Only one horse tram survives, when the Concorde museum opens at Filton in 2017, visitors will be able to see it.

Old horse-tram depot.

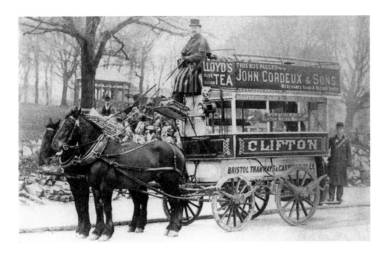

A horse-tram.

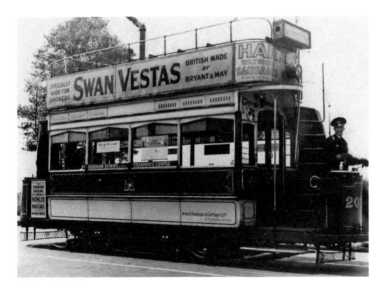

Bristol tram.

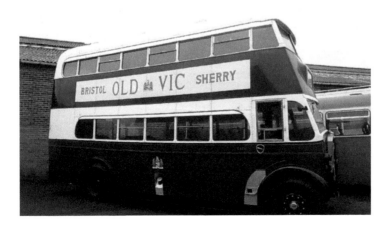

Bristol bus in original colours.

Tramlines at Gloucester
Road Medical Centre.

DID YOU KNOW THAT...?

When you notice an old-fashioned bus driving past, the chances are it is a working
exhibit from the Bristol Vintage Bus Group's collection on Flowers Hill, site of the
old Bristol Bus Works. The BVBG welcomes visitors and recruits.

The only surviving tram tracks in Bristol are in the car park of Gloucester Road
Medical Centre.

Bristol Tramways was transferred to state ownership in 1948 when the new Labour
government nationalised the transport industry, but it continued to expand, taking over
other bus routes and companies. Bristol Tramways changed its name in 1957 to the Bristol
Omnibus Co., and continued to create new routes. In its heyday it ran 1,200 buses, some
of them in towns as far away as Hereford and Oxford, many providing a public service in
rural areas for people who would otherwise have been isolated. Sadly, Bristol Omnibus
Co. blotted its ethical copybook in 1963, attracting adverse publicity when it emerged that
it was operating a colour bar by refusing to employ black and Asian crews. Campaigner
for racial equality, Paul Stephenson, exposed this shameful discrimination by sending a
recent immigrant from Jamaica, eighteen-year-old Guy Bailey, to apply for a job. When he
was turned away on grounds of race a boycott followed, inspired by the tactics of the Civil
Rights Movement then on the rise in America. After sixty days the company capitulated,
and both Paul Stephenson, still active in Bristol today, and Guy Bailey later received OBEs
for the stand they made. With growing car ownership, by the era of Margaret Thatcher
in the late 1970s people used buses less, and a lesser-known pronouncement of the Iron
Lady gives an insight into the mentality of the time: 'Show me a man aged forty standing

at a bus stop, and I'll show you a failure.' Privatisation followed, and the Bristol Omnibus Co. with its proud history was broken up, sold piecemeal and absorbed into the National Bus Company and Badgerline. The manufacture of buses at the Brislington works finally gave up the ghost in 1984, but many are still running in countries around the world. There is a fashion nowadays in the USA, Germany and Canada for doing them up to look like red London buses for use in tourist spots.

George White, founder of the Bristol Tramways Co., had other interests in the field of transport. In the early days of the twentieth century he was captivated by the Wright brothers' claim to have made a powered aeroplane, though most people with an aeronautic interest and all the media thought they were liars or pranksters. In 1909 White travelled to France to watch Wilbur Wright take off and land, and the following year he started up the Bristol & Colonial Aeroplane Company – BCAC – in two sheds used by Bristol Tramways at Filton. From the very first his intention was to make aircraft manufacture a commercial enterprise, and to judge how well he succeeded you only have to walk past the vast British Aerospace Systems complex in Filton today. The French were leaders in aviation in White's time, and after BCAC dismantled one of their Zodiac biplanes the first Bristol biplane was built and flew in July 1910, five months after the company's birth. It became known as the Boxkite and was an immediate success, selling not only to the flying schools for whom it had been intended, but also to the War Office. Boxkites were exported but the plane's potential was limited, and in the years that followed White set up his secretive X Department, drawing in designers from around Europe. In 1911, aware that he was ageing and would eventually lose his powers, George White handed over the

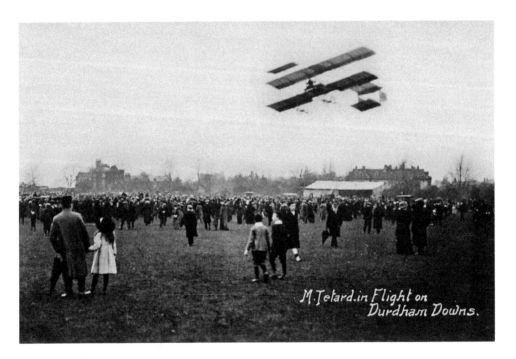

M. Tetard. in Flight on Durdham Downs.

A flight over the Downs.

direction of BCAC to his son, G. Stanley White. As the company grew, operations were moved to the tramways works in Brislington, and by the outbreak of the First World War in 1914 a couple of hundred people were working there. At the beginning of hostilities the potential of aircraft as fighting machines had not penetrated the War Office, so although the Royal Flying Corps and the Royal Naval Air Service, forerunners of today's RAF, had some aeroplanes they were unarmed and their only role was the monitoring of troop movements and enemy positions. At first the War Office resisted the purchase of the Bristol aircraft, but the RFC and RNAS pilots were adamant about wanting the superior planes, and when orders were placed for a single-engine reconnaissance aircraft, the Bristol Scout, the Brislington works grew to accommodate the work. When reconnaissance flyers on both sides began to fire at each other with pistols and rifles, machine guns were fitted on the biplanes' top wings so that they could fire over the propeller, although it was realised that directly forward-firing guns would be more effective. A Dutch aircraft engineer working for the Germans, Anthony Fokker, overcame this problem in 1914, and by the following summer Germany dominated the skies. Early in 1916, though, a downed Fokker was examined by British engineers, and by autumn the Allies had caught up. By the time White died at his home in Stoke Bishop on 22 November 1916 he had become Sir George White, Baronet. In the same year his son, George Stanley White, manufactured a vital component of the war effort, a new biplane called the Bristol Fighter. One of the most important weapons in the British struggle against the threat of German air supremacy, this aircraft stayed in service until the early 1930s.

By the end of the First World War, the company had introduced monoplanes and the Brislington works had a workforce of around 3,000, but the signing of the Armistice brought a huge loss of orders and almost bankrupted BCAC. To keep going, White used all his resources to set up a works making bus bodies for his sister company, Bristol Tramways, and introduced a light car called the Bristol Monocar. In 1920 the old company name was dropped and the Bristol Aeroplane Co. came into being; the list of aeroplanes it produced is too long to be recorded here. To pilots, its aircraft had always been known by the name of Bristol, and this now became their official title. At this time, too, the company took over a Fishponds firm, Cosmos, and developed an aero engine that dominated the world. By 1935, the Bristol Bulldog had been the RAF's main fighter for five years and was being exported in large numbers. The BAC workforce was then 4,200. When the Bulldog was withdrawn from service in 1937 it was quickly followed by the Blenheim light bomber, the first aircraft to have retractable landing gear and a powered gun turret. When the Second World War broke out in 1939, BAC Filton was the world's largest aircraft manufacturer, occupied with the production of aircraft like the Bombay, whose main theatre of operations would be the Middle East, and the twin-engine torpedo bomber and Blenheim successor, the Bristol Beaufort. Beauforts made under licence in Australia were used by the Royal Australian Air Force in the Pacific right up to VJ Day. This aircraft, in turn, developed into BAC's most vital contribution to the war effort, the heavier Beaufighter, a long-range night fighter that had the ability to land without the runway lights that made airfields an easy target for German bombers. This versatile plane was used by Britain and her Allies, including the USA, throughout the Second World War.

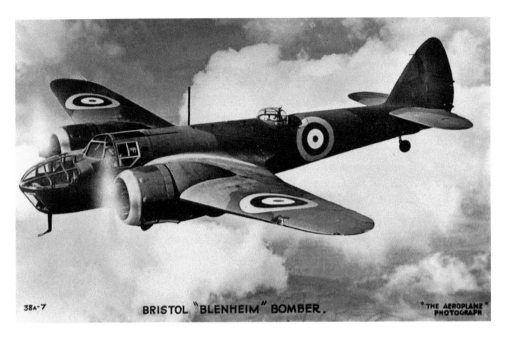

38A-7　BRISTOL "BLENHEIM" BOMBER.　"THE AEROPLANE" PHOTOGRAPH

Blenheim.

After the Second World War, with a workforce of 70,000 and determined not to be caught out by a catastrophic loss of orders as had happened to his father in 1918, Sir G. Stanley White quickly diversified in several directions so what could have been a recession turned into an era of growth. As early as 1941 his own son, the founder's grandson, George White, was investigating the feasibility of making hand-built, high-performance cars, and in the very month of the German surrender, May 1945, BAC took over the sports car maker, Frazer Nash. A manufacturing base was set up at Patchway, and the first Bristol 400 car rolled off the production line in 1946. This successful car continued to be developed, and in 1955 a Bristol 450 won its class at the 24 Hours of Le Mans race. Immediately after the Second World War, also, BAC began to manufacture helicopters in Weston-super-Mare, an operation that continues today as Westland. At the same time, the company turned its collective hand to a 'swords to ploughshares' operation and began making prefabricated buildings, although not the beloved prefabs that remain dotted throughout Bristol, these were made by the nearby Gloster Aircraft Company. The Whites saw the need for larger freight and passenger planes in a changing world, and the result was the appearance of the huge four-engine, propeller-driven Brabazon, the world's biggest landplane in 1949. This was too heavy to be practical and never went into service, but it was not a total White Elephant for although BAC abandoned it, its development led to the Britannia. Likewise powered by four propeller engines, it was used by the RAF as a combined troop-carrier and transport plane, and bought by the British Overseas Airways Corporation, forerunner of today's British Airways. Although overtaken by the appearance jet airliners after less than a decade, the plane flew for airlines and freight companies all over the world, dubbed the Whispering Giant because it was quiet.

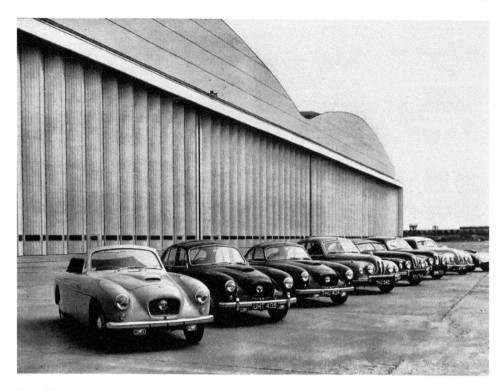

Bristol Cars.

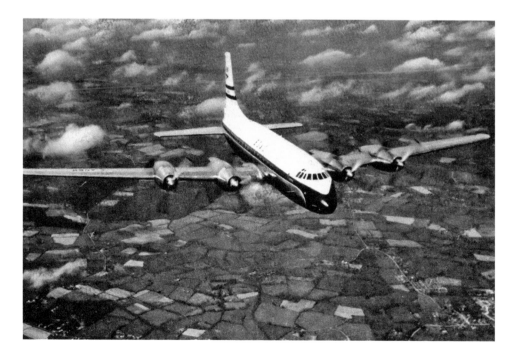

The 'Whispering Giant'.

Pioneering work in developing turboprop technology for the Britannia formed the groundwork for the Concorde, the world's one and only supersonic airliner, unless you count the Russian Tupolev Tu-144. This obvious copy and disastrous failure appeared two years after Concorde and was greeted with derision in the West, where it was known as Concordski. The real Concorde, developed by BAC jointly with the French company Aérospatiale, first flew in 1969 and went into service in 1976. An object of beauty as well as an engineering triumph, it could fly at twice the speed of sound and cut transatlantic flying times by more than half. In economic terms a loss-maker that needed to be underwritten by the British and French governments, it nevertheless flew until 2003, although its only crash in 2000 spelled its doom. Taking off from Charles de Gaulle airport, it hit debris on the runway which led to a ruptured fuel tank and caused it to crash into a hotel, killing all on board as well as four people on the ground, a total of 113 souls. By this time, BAC and Aérospatiale had merged to form Airbus, and when the new company declined to continue servicing the Concorde it was left to die. Its final flight was on 26 November 2003, and few Bristolians will forget its graceful return over Brunel's Clifton Suspension Bridge on its way to its final home on the site of Sir George White's factory in Filton. An impromptu museum was set up but proved untenable, but Heritage Lottery funds for a new one to be managed by the Bristol Aero Collection have now been granted, with off-shoots of BAC like Airbus, Rolls-Royce engines and BAE Systems all pledging support. Today, Bristol employs 6,000 people designing and assembling wings for all the

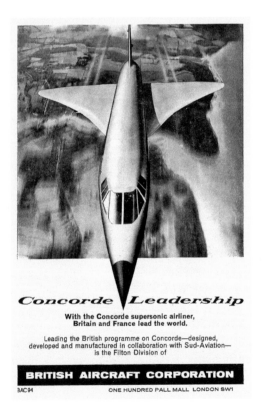

Concorde Leadership

With the Concorde supersonic airliner, Britain and France lead the world.

Leading the British programme on Concorde—designed, developed and manufactured in collaboration with Sud-Aviation— is the Filton Division of

BRITISH AIRCRAFT CORPORATION

BAC94 ONE HUNDRED PALL MALL LONDON SW1

Concorde advertisement

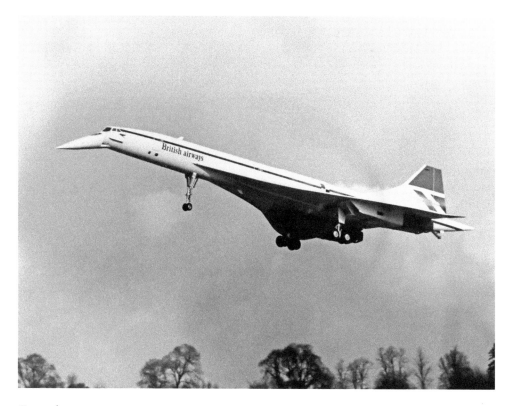

Concorde.

Airbus planes. In February 2015, the RAF recognised Bristol's role in aircraft manufacture by naming the UK's first new military transport plane, the A400M Atlas *City of Bristol*.

Although George White and his successors were the leaders in transport manufacture in Bristol, theirs was not a monopoly. Invited to Kingswood to repair boot-making machinery in 1882, William Douglas moved there from Greenock in Scotland followed by his brother, Edwin. After borrowing £10 to start a blacksmith business, they successfully manufactured drain covers and lampposts, and in 1902 one of their customers, Bedminster designer Joseph Barter, had the novel idea of fitting a small petrol engine to a standard bicycle frame. The Douglas brothers made castings for Barter's company and when he went bust in 1907 they brought their own, improved version of his motorcycle into production, and began a transport revolution. Sales grew rapidly, soon they added a sidecar, and during the First World War they sold 70,000 machines to the military. The brothers' workshop had grown into a huge factory by their heyday during the 1920s, but in the 1930s sales began to fall. They diverted into manufacturing cars, milk floats and industrial trucks, but to no avail. The troubled company received a fillip when they gained a license to manufacture Vespa motor scooters in the 1950s, but their machines lagged behind those of Italian rivals. Douglas' last motorcycle, the Dragonfly, appeared in 1955 and soon afterwards Westinghouse bought them out. In 1982, exactly 100 years after William Douglas moved to Bristol, the company folded.

The swinging sixties.

4. Down to the Sea in Ships

To recall Bristol Harbour in its nautical heyday, for instance when Robert Louis Stevenson gives his account of Jim Hawkins' arrival there in *Treasure Island*, is to imagine a line of docks packed end-to-end with ships, while Jolly Jack Tar sailors in canvas pantaloons, striped jerseys and tarred pigtails roll barrels or load boxes of goods aboard creaking merchant ships bound for exotic climes. In other words, a vivid place of constant activity. Surprisingly, now that the commerce has gone, that is how Bristol docks are today, a vibrant area bustling with life. To discover this for yourself, follow the Long John Silver Trust's informative Treasure Island Trail, beginning at the Merchant Venturers' almshouse at the city centre end of historic King Street. First stop is the wonderful Llandoger Trow pub, reputedly the inn where Daniel Defoe met Alexander Selkirk, whose tales gave him the inspiration for *Robinson Crusoe*.

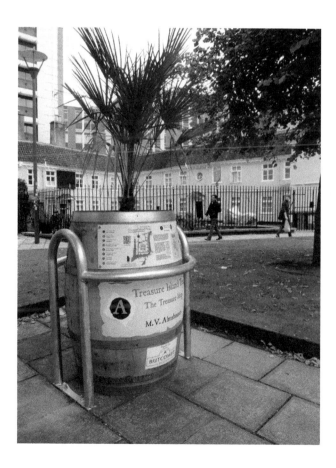

Treasure Island Trail.

Next stop on the Treasure Island Trail is on Welsh Back, so called because houses owned by merchants who traded with Wales once backed onto the harbour there. Now a place of bars and eateries, at its end on the right the visitor will reach the Hole in the Wall pub. This was almost certainly Robert Louis Stevenson's model for the Spy-Glass Inn in *Treasure Island*, having entrance doors in two streets and 'a large, low room' as he describes. It has a unique feature on its harbour side, a small room with a slit in its wall through which drinkers looked out for the press gangs who once kidnapped men here, taking them out to sea where they had no choice but to sign up for the navy. From there, the trail takes us over the bridge to Redcliffe Wharf where the *Matthew* was built and from where she was launched to the nearby Redcliffe Caves – the subject of many myths and legends. Turn right onto gentle Redcliffe Hill opposite the church, and if you follow the trail down Guinea Street you will find yourself on Bathurst Basin, built by Bristol MP Charles Bathurst (1754–1831) where the River Malago ran into a pond at a place called Trinn Mills.

When the Floating Harbour was built and the Avon bypassed into the New Cut the millpond lost its water supply, and in its place Bathurst built a lock that allowed smaller ships to avoid Cumberland Basin and sail directly into the docks. Beside it, this resourceful entrepreneur built an inn for returning sailors which he modestly named the Bathurst Tavern. At that time Bedminster was still largely agricultural, and to give a commanding view over its pastures he had a local smith design and build a veranda on two of its sides, giving his tavern a New Orleans look. Up until the early 1960s the pub continued to cater for seafarers, and its architectural quirkiness allowed a later owner to rename it the Louisiana. On the opposite side of Bathurst basin stands the old Bristol General Hospital, opened in 1832 by Quakers concerned at the lack of healthcare in the growing industrial area of Bedminster. The BGH closed in 2012, and the site is now being developed as apartments and shops that retain its original feel. Between these two iconic buildings floats the lightship *John Sebastian*. Built in the nearby shipyard of Charles

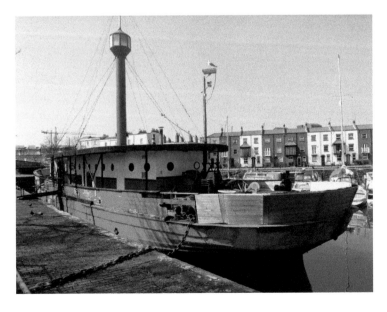

The *John Sebastian*.

Hill & Co. in 1885, she was bought by the Cabot Cruising Club in 1954 and is still in their clubhouse. The lock that fed Bathhurst Basin was closed permanently during the Second World War amid fears that it could be bombed, flooding the docks at high tide.

Passing brightly painted narrow-boats converted into homes, the walker may notice a blocked-off tunnel before the next point of the trail, the eighteenth-century Ostrich Inn on the right. The old docks railway once ran from Isambard Kingdom Brunel's Temple Meads station, (a fusion of fairy-tale castle and Kremlin), alongside St Mary Redcliffe Church before smashing its way through Redcliffe Caves onto the docks via a steam-powered bascule bridge, where the blue pedestrian bridge now stands. Built around 1745, the Ostrich has a unique feature–a cave in its bar. As this was once connected to Redcliffe Caves, stories abound about it being a prison or a hiding place for smugglers, and the pub has taken advantage of this by placing a skeleton inside. Crossing over the footbridge and walking along the docks gives a good view of the Mud Dock on the far side and the Thekla music venue which, unusually, is a ship. Built in 1959 in Germany, she was given a U-boat engine left over from the Second World War and carried timber to England from the Baltic for decades. After running aground at Gravesend, she rotted for years before being acquired by Vivian Stanshall of the Bonzo Dog Doo Dah band, and taken to her present location.

Passing more houseboats, the walker will reach Wapping Road and see the cranes on Wapping Wharf lying straight ahead. The Treasure Island Trail ends here, although our pedestrian voyage of discovery does not. The walker has a choice. By crossing Prince Street Bridge he/she can return to the inner harbour, where the historic Shakespeare pub on the left backs onto the Floating Harbour with its Arnolfini arts centre, unkindly called the 'Analphoney' by some. Across Pero's horned bridge lie the Watershed cinema, waterside bars and Millennium Square, a planetarium, aquarium, and the @Bristol centre for hands-on science. No secrets here, although the sculptures are worth checking out.

The more energetic may choose to continue onto Wapping Wharf where the classic MV *Balmoral's* berth is on the right. Built in 1949 for the Red Funnel Fleet, she ferried passengers to and from the Isle of Wight before coming to Bristol in 1985, since which time she has carried two million passengers on day excursions around the coast. Cared for by volunteers, she was laid to for a couple of years but is now back in service. During the summer months a remnant of the old docks railway runs nearby, a steam train that charges a small fee to take visitors along the harbour to the SS *Great Britain*. The train is powered by two engines, the *Portbury*, built in Fishponds in 1917, and the *Henbury*, also Bristol-built in 1937. To the left stand the four dockyard cranes built in Bath by Stothert & Pitt in the 1950s. They have been restored to full working order and are owned by the M Shed museum which lies beside them, crammed with interesting exhibits about Bristol's past.

Although a harbour is by nature a place where vessels constantly come and go, Bristol has some permanent residents like the tugboat, *John King*. Built in 1935, she was strafed by enemy aircraft in the Bristol Channel during the Second World War as she returned from fire-fighting duties in South Wales. In 1970, *John King* briefly became a TV star when she towed SS *Great Britain* into Bristol docks on her return from the Falklands. The nearby *Mayflower* tug is much older. Built in 1861 and thought to be the world's oldest tug, she

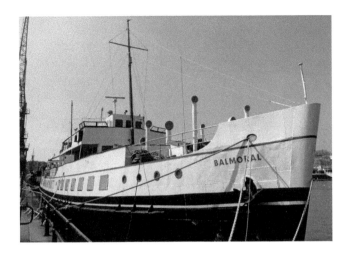

MV *Balmoral*.

The *Portbury*.

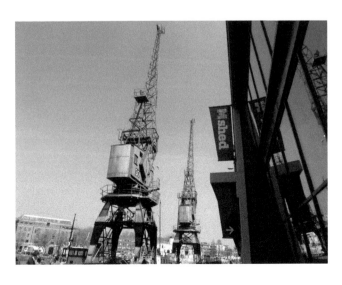

Dockside cranes.

worked for 100 years on the River Severn. The fire ship *Pyronaut*, built in Bristol in 1934 and moored in the harbour, fought ship fires for around forty years, most notably during the Blitz when Bristol docks came under sustained German attack. On the harbour, too, the visitor will see the Fairbairn steam crane. Built by Stothert & Pitt in 1878 to the design of a Victorian engineer, William Fairbairn, it could lift 35 metric tonnes and was taken out of mothballs for use in the Second World War. Trips are available on the *Mayflower*, the *John King* and the *Pyronaut*, as are rides inside Fairbairn's crane and the four electric cranes (details at https://www.bristolmuseums.org.uk/m-shed/). Beside the M Shed lies the berth of the *Matthew*. You can go aboard for free and find out about her history, and trips around the harbour are reasonably priced.

Continuing along the harbourside, past swishy apartments with acres of gleaming windows on the left, to the right dozens of craft lie moored, mostly Bristol-registered and ranging from canal barges to millionaires' yachts. A ship's anchor embedded in the dockside marks the location of the Bristol Packet, whose fleet of pleasure craft do tours around the harbour and beyond, and then it is the magnificence of the SS *Great Britain*, now an award winning museum. Follow the sign Harbourside Walk behind it and you will pass the Orchard, a traditional Bristol cider pub, carry on towards Abels' shipyard and on the left, hidden down a dead end, is Banksy's cheeky tribute to Vermeer's *Girl with a Pearl Earring*, the *Woman with a Pierced Eardrum*. Continue past Bristol Marina and the Cottage pub on Baltic Wharf and you can walk through the Underfall Yard with its nautical businesses, to the unspoilt Nova Scotia pub for a well-earned, waterside drink.

Bristol has a history of piracy. The world's most infamous pirate, Blackbeard, was born Edward Drummond in Redcliffe around 1676, later changing his surname to Teach to protect his family. At 6-feet 4-inches in height, at a time when people were smaller than they are today, to terrorise his enemies he went into battle all in black with pistols strapped to his chest and fuses burning in his hair and beard. Blackbeard preyed on shipping in the

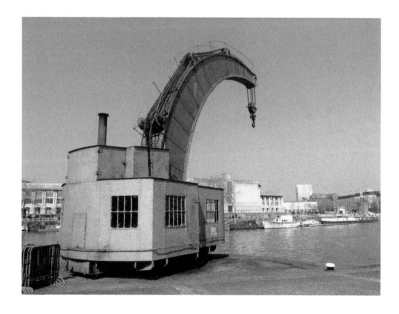

The Steam Crane.

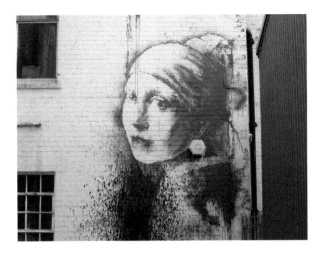

Girl with a pierced eardrum.

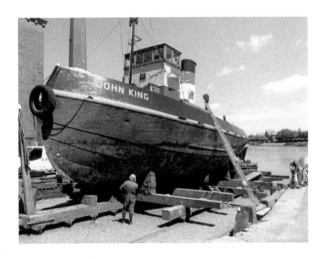

John King in the Underhill Yard.

Caribbean and America's east coast for almost twenty years in the early 1700s, during which time he captured forty ships and earned himself a reputation for cruelty that was second to none. His end came in November 1718 at the hands of Royal Navy Lt Robert Maynard, who was sent to deal with him in his better armed, more seaworthy ship, the *Ranger*. The two met off the coast of North Carolina and Blackbeard could have fled, but from arrogance or foolishness, chose to fight. Making the pirate believe they had abandoned ship, Maynard craftily went below with his men and hid, then ambushed Blackbeard and his crew when they boarded the *Ranger*. Blackbeard took a pistol shot while swinging his heavy cutlass, and was about to despatch Maynard when he received a neck wound from a Scottish rating. The pirate continued to fight until he fell down dead with twenty-five sword wounds and five pistol balls in his body. Maynard had him decapitated, hung the severed head from the *Ranger's* bowsprit and sailed proudly for home.

It is difficult to imagine a bullying buccaneer who was also an explorer, a map-maker, ornithologist, botanist, a skilled artist and England's first travel writer, but William

Dampier, born in East Coker, Somerset in 1651, was all these things. Apprenticed to a shipmaster in Weymouth where he developed a love of the sea, after learning his seafaring art on a voyage to Newfoundland, at twenty years of age he honed his navigational skills when he set off for Java in the Pacific via the Cape of Good Hope. When that had been reached he sailed with privateers and out-and-out pirates to pillage Spanish ships. His next major voyage took him to the Philippines and from there to Australia, and as he travelled he made notes of everything he saw, accompanied with illustrations. Marooned in the Bay of Bengal, Dampier cadged lifts on different ships and arrived back in England at the age of forty, having circumnavigated the globe but with nothing to show for it beyond his journals.

Always resourceful, Dampier turned his hand to writing, and in 1697 published *A New Voyage Around the World*. Together with his later works, the book brought new words into the English language such as barbecue, chopsticks and catamaran, and was an immediate best seller, attracting the interest of scientists as well as those looking for a swashbuckling adventure story. Not only that, it reached powerful people in the Admiralty, and with the seizure of new colonies in mind they asked Dampier to suggest a voyage that would increase British influence. He proposed a trip to Australia, then an unknown, almost mythical continent which contemporary maps mostly guessed at. He demanded two stout ships and three years' supplies, but was given a leaky old warship, the Roebuck, and fifty sailors. They set off early in 1699, reached Australia that same year and after a skirmish with Aborigines, sailed for New Guinea where he discovered land which he named, New Britain. Dampier wanted to return to Australia but his sailors demanded a return home as the Roebuck's timbers had fallen prey to the shipworm, *Toredo navalis*. This menace caused wooden ships to disintegrate and the only remedy was to cover their hulls with copper, the origin of the phrase 'copper-bottomed'. The *Roebuck* had to be abandoned at Ascension Island, Dampier was brought back on a different ship but was disciplined by the navy for beating one of its officers, and denied the three years' wages owed to him. He brought back his journals as well as valuable plant specimens, which he gave to the Royal Society, and a second book followed. After two years Dampier set off on another buccaneering venture, seeking a Spanish galleon that carried treasure from Manila, without success. A mutiny followed, and during the course of the voyage one seaman, Alexander Selkirk, was marooned on a lonely island.

DID YOU KNOW THAT...?

In the eighteenth century, the government issued letters of marque to favoured sea captains that allowed them to plunder enemy merchantmen in the form of legalised piracy known as privateering. Seafarers were recruited in dockside alehouses like the Llandoger Trow. The King Street pub often advertised for adventurers in the Bristol newspaper of the time.

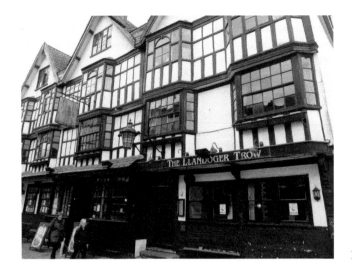

Llandoger Trow.

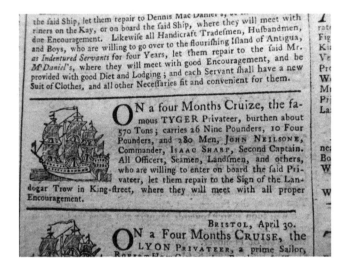

Felix Farley's *Bristol Journal,*
May 1757.

As soon as the Crown dropped its demand for a portion of the privateers' booty in 1708, Bristol Corporation fitted out two ships, the *Duke* and the *Duchess,* carrying fifty-six guns and over 220 armed sailors, and gave their command to the man who would become the city's most famous buccaneer, Captain Woodes Rogers. The second largest investor was Dr Thomas Dover, who had sailed on slave ships, first as surgeon, later as captain. 'A man of rough temper,' Dover had graduated in medicine at Oxford, and in 1695 had offered his services free to St Peter's workhouse in Bristol. At sea he was known as Cap'n Quicksilver, while on land they called him the Quicksilver Doctor because of his fondness for prescribing mercury, particularly for treating venereal diseases. He sailed as mate on the *Duke,* Woodes Rogers was captain of the *Duchess* where Dampier, now on his third circumnavigation of the globe, was his pilot. They bravely headed for the most southerly part of South America, Cape Horn, with its treacherous weather, high seas and icebergs,

and seeing a light on the tiny island of Más Afuera, which means further out, they decided to hove to for the night. To their amazement a figure clad in goat skins approached them. This was none other than Alexander Selkirk, marooned there four years earlier, later the model for *Robinson Crusoe*, written by Daniel Defoe after he reputedly met Selkirk in Bristol, and had read Captain Rogers' books.

A good seaman, Selkirk took over Dampier's post as mate of the *Duke*, and early in 1709 the convoy of three privateers captured five Spanish ships and extracted a ransom of 30,000 pieces of eight, the silver coin minted in Spain, from a town they occupied. In one fierce battle Captain Rogers was hit by a bullet that took away part of his upper jaw and many of his teeth, and in another a splinter of timber hit by a cannon knocked a chunk out of his heel. Despite such hardships, they captured a Spanish treasure ship and his flotilla sailed back into Bristol in 1711 bearing a vast profit totalling around £175,000, equivalent to £20,000,000 today, for their main backer, Thomas Goldney II of Goldney Hall in Clifton, now a University of Bristol hall of residence. Shells brought back by Dampier still decorate the grotto there, and a pair of silver candlesticks, either seized from the Spanish or made from the profits of the raids, were presented to Bristol Cathedral where they remain today. There were delays in paying out the booty, and William Dampier is believed to have died in penury in London in 1714, still waiting. Capt. Woodes Rogers bought No. 19 Queen Square as his residence but lost it for a time as a result of litigation, and to raise money he wrote a book based on his log, *A Cruising Voyage Around the World*. Published in 1713, it was a best seller and provided inspiration not only for Defoe, but also for Robert Louis Stevenson. Cap'n Quicksilver lost his fortune when the South Sea Bubble burst, but like Rogers he wrote a best seller, *The Ancient Physician's Legacy*. He also invented a medicine, Dover's Powder, which survived into the twentieth century and was used by Henry Morton Stanley, utterer of the famous phrase, 'Dr Livingstone, I presume?'

Grotto entrance at Goldney Hall.

In 1717 Woodes Rogers offered to tame the Bahamas, a haven for pirates. Appointed governor, he arrived the following year with three ships, escorted by two Royal Navy warships, HMS *Rose* and HMS *Milford*. He had several pirates hanged but granted a royal pardon to over 200 who had helped him to build up defences and repel the Spanish. Caribbean piracy never really recovered from this blow, and Capt. Rogers later brought his family to Nassau and made it his permanent home. He died there in 1732.

It is easy nowadays to become sentimental about pirates, but most were as cruel as they were ruthless, and upon taking a ship would throw everyone on board into the sea to drown so that they could not be identified later. Their own end was often harsh. Although pirates were hung on the Town Marsh in Bristol during the seventeenth century, most of the later death penalties were carried out at low tide on the River Thames, at Execution Dock below Tower Bridge. Cruelly, the hangings were done with a short rope so that the drop from the gibbet did not break the neck and death came by slow strangulation. Seen as a spectator event, the shore would be crowded with people eager to watch the 'Marshal's dance', as the prisoners' agonised struggle was called, under the watchful eye of the Admiralty marshal. Corpses were left hanging until they had been covered by at least three tides as an example to passing sailors.

5. Church Times

Although it stands in central Bristol, the city's oldest building, St James' Priory, is also one of the easiest to miss. Its antiquity makes it remarkable and its lovingly preserved interior is one which any Bristolian with even a mild interest in their history would enjoy seeing. It is a strange fact that for many, their best known connection with the priory is the White Hart pub, which was its chapel in ancient times. The St James' entrance lies between the pub and the bus station, and today's church is all that remains of a much larger ecclesiastical site that was destroyed with other Catholic institutions during the Reformation. The building, now Grade I listed, was founded as a Benedictine priory by Robert of Gloucester in AD 1129. Importing blocks of stone from Normandy to build the huge keep of Bristol Castle, he donated one in every ten to build the priory. Robert is even buried there, his tomb in the south aisle has a prone statue of him dressed as a knight. High on the wall at the end of the nave there is a round window known as the oculus, the Latin word for eye, whose design is mirrored in the decoration around the chancel. In the north aisle, a glass screen made by a Venetian artist represents a broken life that has been repaired, and this is fitting because St James' Priory carries on the Benedictine tradition by supporting people in the community. It provides residential care for those with addictions, and helps people living on the streets via the homeless charity, Mungo Broadway. Still used as a Catholic church, it holds Mass every Sunday at 8.00 a.m. and welcomes visitors of any faith or none, from 10.00 a.m. until 5.00 p.m. from Monday to Friday, and sometimes opens on Saturday.

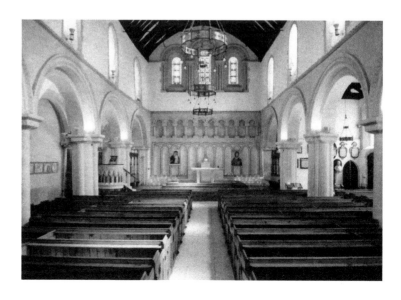

St James' Priory.

Robert of
Gloucester's tomb.

The world's oldest Methodist chapel, the New Room built by John Wesley in 1739, cannot be so easily missed. It has two courtyards, one in the Horsefair with a statue of John's brother, the prolific composer of hymns Charles Wesley, beckoning passers-by to come inside, the other in Broadmead with an equestrian statue of John himself. It was on horseback that Wesley spread his message, and an endearing touch is that his nearby stable has been preserved. Most of the building and contents are original, with the chapel itself on the ground floor and the preachers' rooms on the floor above, which also houses a museum holding artefacts of historical interest, especially to the world's 75,000,000 Methodists. As I stepped into the wood-panelled chapel with its oak pews, a tenor voice rang out in song from the balcony above, and by the time I'd climbed the wooden stairs the singer had been joined by a lady trilling sweetly on the Snetzler Chamber organ, built in 1761. The clock in the Common Room upstairs, dated 1670, belonged to the Wesleys' father. It still runs and chimes although it only has one hand, which made me wish I was wealthy and could have it restored. Francis Asbury was the preacher who took Methodism across the Atlantic, and his room has many American items. John Wesley's rooms stand

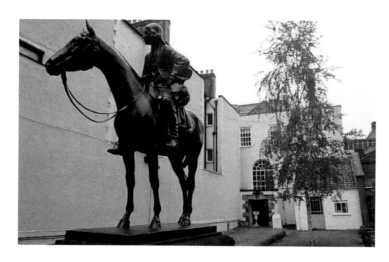

John Wesley's statue
in the Horsefair,
Broadmead.

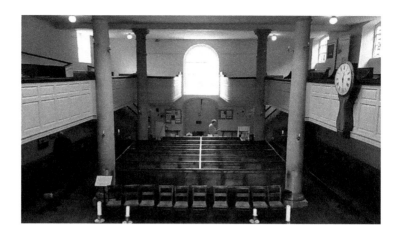

John Wesley's New
Room.

as they were when he stayed here, and the house of Charles Wesley, whose hymns include,
'Hark! The Herald Angels Sing', is nearby. There are frequent events at the New Room,
including free concerts held most Fridays.

A few minutes' walk away stands the fourteenth century St John the Baptist church at
the bottom of Broad Street, known as St John-on-the-Wall because it formed part of the
boundary of the old walled city. Today, St John's and the ancient city gate beside it are
almost the only parts of the wall that remain, and both are steeped in history. In 1535
the Mayor of Bristol, Thomas White, passed through the arch from his home on Broad
Street to attend an audience with Henry VIII at Thornbury Castle, where the king was
staying with Anne Boleyn, unable to come into the city because of plague. In 1555, seven

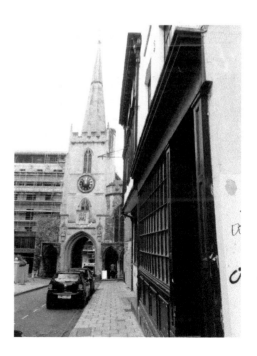

St John-on-the-Wall.

Protestant martyrs were taken through the arch to be burned on St Michael's Hill on the orders of Queen Mary, and in 1574 Elizabeth I stood in the church porch to hear an address from Bristol worthies. During the English Civil War (1642–1651) its crypt was used as a prison. A stone's throw away stands St Stephen's. Built outside the ancient city walls, it has a feature that is probably unique in a church building: arrow-slits facing out from the old city so that it could be defended. St Stephen's has a bookshop in its grounds and a café where you can meet a wide cross-section of Bristolians. The staff will unlock the building on request and there are some beautiful memorials inside like that of explorer Martin Pring (1580–1626), the discoverer of Cape Cod Bay, which artistically recalls his life, and the tombs of Sir Walter Tyddersley and Sir George Syngge.

At the top of Broad Street stands Christ Church with its impressive arched interior, built on the site of a far older church, whose organ was replaced in 1643 after damage during the Civil War. The church was rebuilt in 1784 but a fifteenth-century oak chest from its predecessor stands by the font, decorated with a flying dragon. The poet laureate Robert Southey (1774–1843) was born next door in Wine Street and baptised here. Christ Church still takes its music seriously, holding concerts and sung services. One remarkable feature is the ornate clock outside. The two Quarter Jacks, figures that struck a bell every fifteen minutes, were enjoyed by locals and visitors alike, but sadly they were taken down for restoration some years ago and have not yet been replaced. Could a commercial city like Bristol not have a whip-round among its millionaires, and get this done?

Before Bristol Bridge stands St Nicholas' Church. Again, the Grade II listed building stands on the site of a far older church, the crypt dates from the 1300s and statues from that period remain inside. St Nicholas' was bombed in 1940 and has never been used as a church since, it is home now to Bristol & Region Archaeological Services. The building houses a triptych painted by William Hogarth in 1755, and although the church is not open to the public if you ring the bell a staff member will happily let you in to view it, and give you a colour brochure about it. This huge triptych, originally commissioned by St Mary Redcliffe, has a centrepiece seven metres high and six wide.

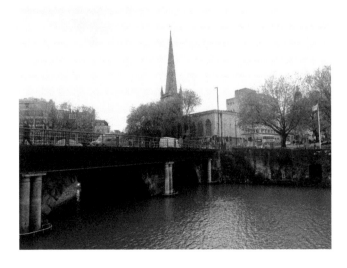

Bristol Bridge and St Nicholas'.

As in all British cities, many church buildings in Bristol have now been put to different use. An outstanding example of this is the former Zion Methodist church in Bishopsworth, now a non-profit community arts centre. There are regular parent-and-toddler groups, a little music band and crafts for younger children, a deli, a café that does wonderful food and sells Bristol Beer, and the building with its spectacular balcony covering three walls is also used as a gallery, cinema, music venue, market and theatre. Look online and give Zion a whirl, you won't be disappointed.

'The fairest, goodliest and most famous parish church in our Realm,' is how Elizabeth I described St Mary Redcliffe on her visit in 1574, and it's true, the building is more like a cathedral than a simple parish church. A Gothic masterpiece, it was completed in the 1360s by William Canynges senior and known then as St Mary de Radeclive. Canynges' grandson, William Canynges Jnr, spent a fortune bringing the church up to date in 1442. This second Canynges, a wealthy ship owner who was five times mayor of Bristol, has two tombs inside, for when his wife died he gave up his wealth and became a priest. St Mary's contains treasures too numerous to mention here, including stupendous carved ceiling bosses and stained-glass windows, and many tombs and gargoyles.

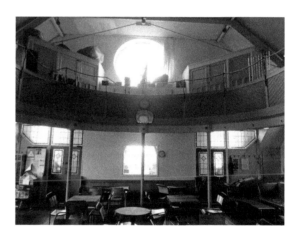

Zion Arts Centre.

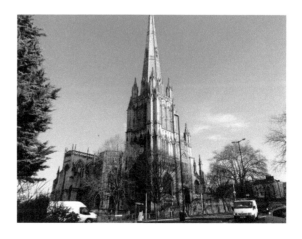

St Mary Redcliffe.

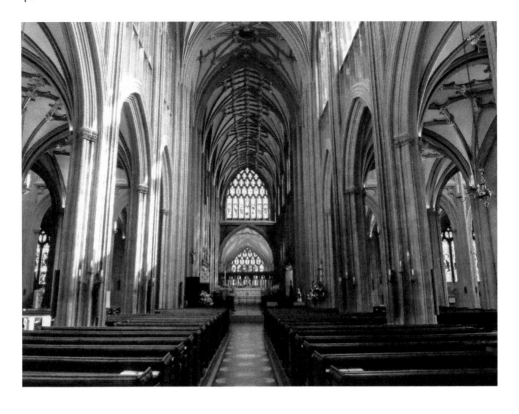

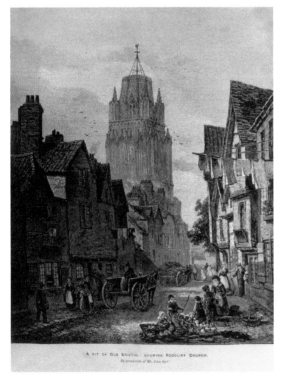

Above: Inside St Mary Redcliffe.

Left: St Mary Redcliffe without her spire.

From the grandest church in Bristol, we travel now to what surely must have been the smallest. Only recently converted for use as a private home, the only giveaway about the tiny church in the row of former quarrymen's cottages at Snuff Mills is its Gothic windows and door. You can reach Snuff Mills by walking along the lakeside path in Eastville Park, then simply following your nose. Carry on for a short way beyond the cottages and you'll come to a café selling home-made cakes and scones, with a delightfully ramshackle shelter overlooking the River Frome. Cross the carpark to the Snuff Mills beauty spot, a favourite haunt for dog-walkers, families with children, couples and singletons, where the mill wheel still turns and you will learn the legend of Snuffy Jack.

Cottage church at Snuff Mills.

Snuff Mills.

6. The 'African Trade'

Walking through Bristol, I often feel I am treading on the corpses of murdered Africans. The Royal African Company of London, whose Elephant & Castle logo is still found on pub signs throughout England, had a monopoly on the slave trade until 1698, and the moment this was dissolved a Bristol ship, the ominously named *Beginning*, set off to take slaves from Africa to Jamaica. The trade grew rapidly, money poured into the city as a result, and most of Bristol's best-loved buildings were built directly or indirectly on the suffering it created. The university's hall of residence, Goldney Hall in Clifton, was built partly on slave money as were the Corn Exchange and its near neighbour, the Old Bank in Corn Street. The merchants who financed the building of the Theatre Royal got their money in whole or largely in part from 'the African Trade,' which also paid for Orchard Street, Queen Square including the Custom House, and the elegant dwellings on Redcliffe Parade. The Georgian House in Great George Street was the home of the fabulously wealthy, slave-owning Pinney family. The Prince Street terrace that includes Bristol's oldest continuously running pub, the Shakespeare, were houses built for slavers by John Becher and Henry Combe, who gained their own wealth from slave plantations in the West Indies. A Capt. Edmund Saunders who lived in Guinea Street, which was named for slavery and built on its profits, commanded twenty slaving expeditions yet held the post of warden at St Mary Redcliffe church, which still contains memorials to slave merchants and the owners of slave ships.

Frieze in the Corn Exchange.

The name of Edward Colston occurs throughout the city in such places as the modern Colston's School, Colston's Girls' School and the Colston Hall music venue. He donated £70,000 – £5,000,000 at today's value – to found a charity school, set up almshouses and maintain vicarages, and was described by Bristol Corporation as 'a person ever memorable for his benefactions and charities' and 'an example of Christian liberality'. Apparently they found it easy to ignore the fact that his wealth was derived from a trade whose brutality had to wait almost two centuries to be surpassed in horror, and only then by Nazi death camps like Auschwitz. Besides slave ships, Colston owned sugar plantations on the Caribbean island of St Kitts, and to the annoyance of many of Bristol's present black population, mostly descendants of West Indian slaves who have come to take their rightful place among us, his statue still has pride of place in the city centre. Slavery not only brought wealth to Bristol, Liverpool and London, it benefited the whole UK economy by creating the stimulus that began the Industrial Revolution.

Colston's statue.

DID YOU KNOW THAT...?

Contrary to local mythology, Whiteladies Road and Blackboy Hill had no connection to the slave trade. The former was built on the site of a Carmelite convent whose sisters wore white robes, while the latter was linked to the Black Boy Inn that once stood there. This may have earlier been called the Saracen's Head: in a grisly reversal of the beheadings favoured by Middle Eastern terrorists today, crusaders sometimes returned bearing a severed Arab head which they hung outside a chosen inn.

There were never any slave markets in Bristol. Slaving was known as the triangular trade because profits were made at each of its three points of exchange. After the ships' outward journey to Africa, the slaves were paid with goods rather than money, with 'beads for the Natives' being joined by mirrors, hats, gin, tools, iron bars, pewter, copper pans and brass bangles, all churned out by Bristol's foundries. Another huge earner was rotgut brandy in glass bottles made in Redcliffe. By far the most numerous exports to Africa, though, and the most damaging to its people, were muskets bought in Birmingham by Bristol merchants, often of such low quality that they blew up in their owners' faces. All these goods made a huge profit when traded for kidnapped human beings and there then followed the infamous middle passage, when the slaves were packed into ships and transported to the Americas. The poor unfortunates who survived this were exchanged there for tobacco, rum and molasses, making another enormous premium. When the ships returned to Bristol the molasses, for instance, was refined into sugar and sold, engendering yet another vast profit: in 1760, there were twenty sugar refineries in Bristol. The wealth derived from the African trade allowed English culture to flourish, and it is no coincidence that the Tate Gallery in London shares a name with the sugar company, Tate & Lyle. Glass kilns worked in Redliffe until the 1930s, and Bristol Blue Glass is still a going concern. Yet if Bristol presently enjoys wealth triggered by the slave trade, the reverse is true in Africa. The continent has yet to recover from over a century during which its strongest people were plundered and tribe was set against tribe, for it was mostly Africans who carried out the kidnapping, overseen by whites who paid them when they brought their victims to the Slave Coast, which extended from the Gambia to Angola.

African villages were raided at night. The people were dragged from their homes in confusion, battered into submission and coldly examined, poked and prodded like cattle so that only the fittest were chosen. Families were torn apart, husbands were separated from wives, children from parents, and the strongest victims were chained together for the forced march to the ships, a journey that grew ever longer as coastal communities were decimated and the slavers ventured deeper into the interior. Millions, literally, perished on these death marches, and countless numbers died in the slave-forts on the coast. Many were terrified upon seeing the sea, but worse horrors waited as they were branded with red-hot irons and packed into ships that still stank from their last 'cargo'. Forced to lie on three or four wooden decks, side by side with only a space of sixteen inches (forty centimetres) for each person, the stronger or more aggressive men were chained by the neck so that they could not reach the overflowing lavatory buckets but were forced to lie in their own filth. Ships were supposed to carry one slave for every ton of their unladen weight, but they were usually overloaded. Anyone who has spent time in the tropics will know the fierceness of the heat, even in a ventilated room. The holds of the slave ships were a living hell. Sickness and dysentery were rife, and these floating coffins could be smelled before they appeared over the horizon. The sailors themselves were not immune and many died, yet their fatalities were light compared to those among the slaves, on a middle passage that lasted from six to twelve weeks.

At the start of the passage, nets were fixed inside the rigging so stop them gaining release from their torment by jumping to their deaths, nevertheless many managed to do

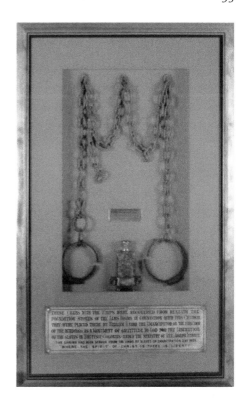

Right: Slave chains (courtesy of the Baptist Union).

Below: Plan of a slave ship.

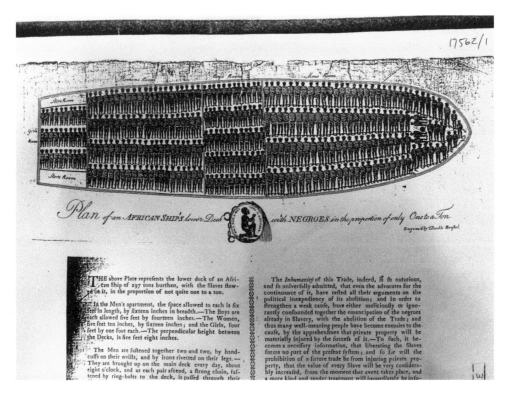

so, while those who died on board were unceremoniously dumped into the sea. In some cases when disease broke out, captains had their entire complement of slaves simply thrown overboard to drown so as to claim their loss on their insurance as 'jettisoned cargo', as though they were not human beings but lengths of timber, or barrels of tobacco. It is estimated that European slavers took between nine and twenty million Africans to slavery in the Americas, and as many again are thought to have died either on the forced marches to the coast, awaiting transportation in the slave-forts, during the horrific middle passage or soon after their arrival, for around one-third perished within three years. In the first half of the eighteenth century, it was cheaper to work slaves to death and buy new 'stock' than to care for existing slaves. Treatments were harsh. Some men had their limbs burnt as punishment for attempting to escape their masters, and were left to die a slow, agonising death as an example to their fellow slaves. Frequent floggings gave rise to the West Indian expression 'blood clot' which has nothing to do with menstruation, but refers to cloths used to wipe bleeding backs. Slave women were routinely raped by their white masters and this is the root of the universal term 'motherfucker' among black people, since children often saw this happen to their mother. Nevertheless, God was often invoked on the side of slave owners. John Pinney, plantation owner on the island of Nevis and master of the Georgian House in Bristol, wrote: 'I was shock'd at the first appearance of human flesh for sale. But surely God ordain'd 'em for the use and benefit of us: otherwise his Divine Will would have been made manifest by some particular sign or token.' Pinney's scruples did not prevent him from later selling his slaves to Edward Huggins, an owner renowned for his cruelty.

As the century approached its close, slave prices rose and feelings in Bristol turned against 'the respectable trade.' Baptist preachers at the chapel in Broadmead spoke out against slavery as did John Wesley at his nearby New Room, and the poet Samuel Coleridge gave impassioned speeches against it. In 1787 this satirical poem appeared anonymously in the *Bristol Gazette*.

> I own I am shock'd at the purchase of slaves,
> And fear those who buy them and sell them are knaves;
> What I hear of their hardships, their tortures, and groans
> Is almost enough to draw pity from stones.
>
> I pity them greatly, but I must be mum,
> For how could we do without sugar and rum?
> Especially sugar, so needful we see?
> What? give up our desserts, our coffee, and tea!

In fact, it was the work of William Cowper (1731–1800). In June of the same year, 1787, a man called Thomas Clarkson (1779–1846) arrived in Bristol. He was a big man, 6-feet-tall in an age when people were much smaller than now, and he had red hair. Two years earlier, he had won First Prize at Cambridge for an essay in Latin called, 'Is it lawful to make slaves of others against their will?' Riding back to London afterwards he had stopped, thought it over, and decided to campaign against the trade, something he did

tirelessly for the rest of his long life, riding thousands of miles and visiting hundreds of ships in his quest for evidence. Of his arrival in Bristol, he wrote in his diary:

> It filled me, almost directly, with a melancholy for which I could not account. I began now to tremble, for the first time, at the arduous task I had undertaken, of attempting to subvert one of the branches of the commerce of the great place which was now before me.

Aware that his enquiry would threaten those in the city who had a vested interest in slavery, at first he blackened his hands and face so as to pass himself off as a coal miner, not to escape their notice but to gain the confidence of working sailors.

This subterfuge became unnecessary when he teamed up Mr Thompson, landlord of the Seven Stars inn in Thomas Lane, then a favourite haunt of sailors, and their partnership is now commemorated by a plaque erected by the Bristol Radical History group. Thompson (first name unknown) knew all about conditions on the slave ships, and when their crews boarded with him he tried to find them berths elsewhere. He took Clarkson to the seamen's taverns in Marsh Street, where he learned first-hand how brutal captains mistreated their crews, as they did the slaves in their holds. The west coast of Africa was known as the White Man's Graveyard, the voyages were fraught with risks of piracy and disease, and though slave ships were a minority of Bristol's ships there were more deaths among their crews than in the all rest put together. Unsurprisingly, sailors were unwilling to engage, and the result was that ships' masters colluded with tavern owners to give them credit, then when they were hopelessly in debt, threatened them with prison if they did not sign up. In other cases, agents would get them drunk and carry them on board so that they woke up at sea, while some men were forcibly kidnapped just like the slaves themselves.

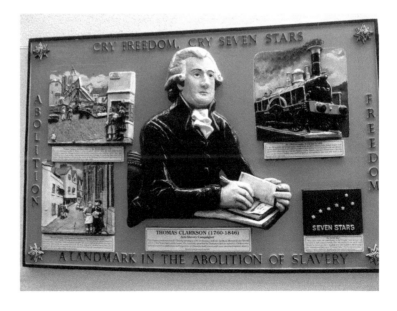

The Seven Stars.

Besides meeting sailors, Clarkson visited ships like the *Pearl*, of whose crew of forty-nine, twenty-two died that year, disproving the owners' contention that slave voyages were a valuable way of training Bristol seamen. The dark hold of the *Fly*, covered by a grating, brought home to him the conditions in which slaves were carried, and it is significant that the following year, 1788, James Rogers and Company, the *Fly's* owners, took out a special insurance covering them against 'Negro Insurrection'. Clarkson also met slave ship surgeons including James Arnold, who told him that owners carried doctors so as to maintain profits by keeping deaths to a minimum, and to examine slaves before they were bought. Arnold described how he had seen slaves flogged and tortured, how African traders who came on board to trade ivory were themselves enslaved, and how, going down into the hold each morning, he found dead slaves who were then thrown to the sharks. Clarkson toured England carrying a box of slave-related objects like branding irons, thumbscrews and neck-rings, and the tide of public feeling slowly turned against the trade. He helped to form the Committee for the Abolition of the African Slave Trade, and when William Wilberforce MP (1759–1833) joined him, slavery's fate was sealed. Boycotts of slave-produced goods began, and with the support of writers and campaigners like Hannah More (1745–1833), born in Fishponds, slavery was at last abolished in the British Empire in 1807. When the slaves were finally given their freedom in 1833, the government paid their 'owners' huge amounts of compensation. So large, in fact, that the Great Western Railway was built upon it.

The slaves received ... nothing.

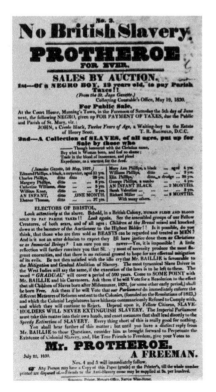

Bristol abolitionists.

7. Law & Disorder

There have been so many riots in Bristol over the centuries, including recent battles with police on Stokes Croft over the opening of a Tesco supermarket, that they cannot fit into this book. Where to begin, then? There can be no better place than in the Bohemian area of Montpelier. Picton Street's appearance has barely altered since Georgian times, yet it is strange that it should stand in an area whose population includes many Afro-Caribbean people because the man it is named after, former Governor of Trinidad, General Picton, was renowned for his cruelty to slaves. As Captain Picton in 1783, he became the hero of Bristol when he quelled a mutiny by leading a sabre charge against rebellious soldiers on College Green, but besides the street and Picton Lodge, the bow-windowed house that stands within it, the general had a torture named after him. Picketing was a military punishment where a man would be tightly trussed and suspended with all his weight on one big toe, which was placed onto a pointed stick fixed to the floor, and the General used this so often during his governorship that it was renamed 'pictoning'. Even in an age when the torture and murder of slaves went unremarked, the General went too far, and after sentencing slaves to death without due process and pictoning a thirteen-year-old free Mulatto girl, Louisa Calderon, he was brought to London to face trial. The process dragged on for years, the killing charges were quietly dropped, and though he was convicted of the pictoning in 1806, this was later overturned on the grounds that torture had been legal when Trinidad was a Spanish colony. The General was killed at the Battle of Waterloo in 1815.

Cutlass in the Church of
St Thomas the Martyr.

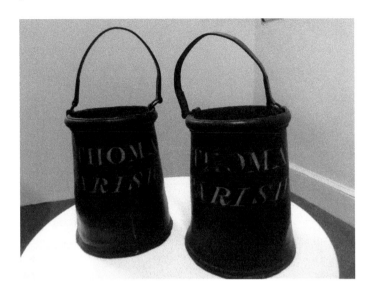

Eighteenth-century fire buckets.

DID YOU KNOW THAT...?

A cutlass found in the street on the morning after a Bristol riot was taken into the church of St Thomas the Martyr for safekeeping. It is still there, kept in a safe. The church also has a number of leather fire buckets, dating from the eighteenth century.

In 1709 wheat prices more than doubled in Bristol, making bread frighteningly expensive. Bristol's growing industries were dependent on coal from Kingswood, and the miners there were a close-knit bunch. Two hundred of them marched into the city and confronted the Corporation, then a private alliance of rich businessmen, and demanded lower prices. The bosses backed down and the price dropped from eight pence a bushel to five. It was a taste of things to come. In 1727, supposedly to finance road maintenance, eight toll gates were built across highways leading into Bristol with every horse or mule passing through them being charged a penny. This time the Kingswood men were joined by miners from Brislington, and numbering around 1,000 they smashed and burned turnpikes, then marched in triumph through the city. The struggle against turnpikes was not over, though. Many were rebuilt, the fight went on for more than twenty years and eventually there were hangings. The resistance fizzled out, but in 1752 the harvest was bad, the cattle became diseased and grain prices rose again. It was reported that, 'a great number of colliers and other disorderly persons' marched on Bristol, beginning a spate of food riots. They were especially angered that grain was still being exported and for a time they occupied a ship, the *Lamb*, which was loaded with wheat bound for Dublin. Soldiers arrived from Gloucester and order was restored, but only briefly, with the miners joined by local weavers when they stormed the Bridewell prison to free arrested comrades.

Through fear of provoking further trouble, the authorities were conciliatory. Concerned citizens set up a fund to alleviate poverty among the miners and the mayor even sent a doctor to treat their wounded. Again, the trouble died down. In 1768 a new Bristol bridge had been built on the foundations of the old one that had been erected in 1245. To pay the £49,000 it had cost, a toll was charged for crossing it with the promise that this would be abolished in 1793. When it was discovered that plans were afoot to charge the toll for a further twenty-one years, disorder followed, and even though merely to damage the hoardings advertising the toll was a hanging offence, the toll gates were attacked and burned. In the ensuing melee, the Riot Act was read repeatedly and eventually soldiers fired into the crowd without warning, killing ten. There were calls for the council to be held responsible, but they blamed the trouble on radicals. Some things never change.

Establishing the causes of riots can be difficult because when they erupt antisocial elements attach themselves, making them spiral out of control. The Bristol Riot in 1831, though, was an organised uprising that put the government in fear of revolution. Caused by electoral injustices and the blocking of the Reform Bill in the House of Lords, it was triggered by the arrival of Sir Charles Wetherell, an opponent of electoral reform who represented Bristol though his seat was hundreds of miles away. When he came into the city on Saturday 29 October, Bristolians expressed their outrage by pelting his carriage with rocks as he drove to the Mansion House in Queen Square, where a crowd of more than 2,000 gathered. The Corporation, still an unelected group of self-seeking businessmen, had foreseen unrest and asked for support, and when only two troops of dragoons were sent they tried to recruit seamen, who flatly refused to help. As luck would have it, a Major Digby Mackworth happened to be passing through Bristol following a punitive incursion against farm labourers in the Forest of Dean, and he swore in a group of special constables known ominously as 'bludgeon men'. When the crowd began to break up and go home, these legalised thugs saw it as a victory and attacked them, inflaming

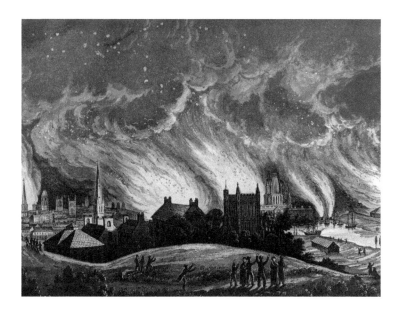

Bristol in flames,
1831.

the situation. Bristol's ancient Bridewell prison had been refurbished in 1770, and when a waggon took arrested men there that evening it was waylaid and its prisoners set free. As windows were smashed in Queen Square the mayor, a member of the old slave-owning Pinney family, read the Riot Act three times, which meant that if more than twelve people refused to disperse for a period of one hour, they would face the death penalty. The rioters' response was to batter in the doors of the Mansion House and ransack it. A banquet had been laid out for the dignitaries and they made short work of this, gorging themselves on chicken and flinging game pies at one another in a spirit of fun. Wetherell escaped by climbing out of an upstairs window and swopping clothes with someone he met on the roof, while the mayor and other officials barricaded themselves in upstairs. As the rioters laid wood on top of straw to burn them out, they followed Wetherell's example and fled over the rooftops.

At that point the hero of the hour, Lt-Col. Brereton, arrived with his dragoons. He found the mob good-natured, but they did not disperse and when two of the dragoons were injured he ordered them to charge, using the flat of their sabres. Running battles ensued and when rioters attacked the Council House, then in Corn Street, a Captain Cage charged them with sabres drawn and several were cut down, including an innocent bystander. At eleven o'clock, rioters boarded the *Weekly Packet of Stroud*, moored on Welsh Back, intent on its cargo of vitriol which they intended throwing over the army horses. On the approach of the dragoons they melted away, and the vessel's Captain Morley pulled her out into the harbour so that when they returned they could not board her.

On Sunday morning Brereton ordered the defenders to withdraw to their barracks and rest, although the prospect of looting had attracted lawless elements and the mood of the mob had worsened. With Queen Square undefended, the rioters returned in force,

The mayor's escape.

smashed their way back into the Mansion House and headed for the cellar to begin drinking its estimated 7,000 bottles of wine. Brereton read the Riot Act again but still refused to let the troops open fire, sending them instead to their quarters near College Green. Harassed on the way, they did open fire and hit several people. Late in the morning, the mayor had notices posted up around the city appealing for help from law abiding citizens, but the bill poster was roughed up by rioters and his pot of paste was jammed onto his head.

The organised nature of the insurrection became clear at 1.00 p.m., when rioters advanced on points of power in the city, beginning with the Bridewell where arrested men were freed, then transferring their attention to the New Gaol on Cumberland Road. The governor, William Humphries, had to watch from the balcony of the nearby Bathurst Hotel, now the Louisiana, as they made a hole in the gates and entered, and his heart must have leapt when dragoons arrived, for by guarding the gates they could have trapped the rioters inside. At the crucial moment, though, their commander received orders from Brereton to do nothing, and they withdrew. The rioters ransacked the gaol, freed the prisoners, set fire to the gallows and the huge, twenty-man treadmill, dragged them out and flung them into the river. The gaol itself was burnt to the ground, so that today only the gatehouse remains. Rioters set fire to the hated toll gates as they made their way to the city's third prison, the House of Correction at Lawford's Gate, where they ran amok, breaking out the inmates and looting. They burned the Bishop's Palace, followed by the Custom House and private dwellings in Queen Square.

With houses ablaze on each of its four sides, the square turned into a huge outdoor market as booty was bought and sold, then taken away in carts, and there may have been as many as 20,000 people standing around at 5.00 a.m. when Maj. Mackworth returned with his dragoons and charged them. Even the dilatory Bereton now became enthused and together they slashed and hacked their way through the crowd, driving looters into burning buildings and slamming the doors so that they burned to death. At least 130 were killed or wounded. Now that the rioters were on the run, troops from the Bedminster Yeomanry bravely turned up, and the rout turned into a massacre. Driven into the old city,

Queen Square riot.

Rioters massacred.

the rioters regrouped and tried to retake Queen Square but they were ruthlessly hunted down by troops commanded by Major Mackworth, who calculated that another 250 were killed or wounded. The total must have been at least 400, but the Corporation gave a more modest figure – twenty. The riot had lasted less than three days, and as the city was flooded with troops a huge search for stolen goods got under way, and forty cartloads were brought to the Exchange. The government overruled the Bristol Corporation's obtuse suggestion that those arrested should be tried before Sir Charles Wetherell, and sent the Lord Chief Justice to try the case. Many were transported or sentenced to prison terms with hard labour and four were hanged at the burnt-out New Gaol, which had been built with a trap door above its gateway to make executions public events. Lt-Col. Brereton was

Riot executions.

court-martialled, and as the extent of his bungling became clear, he went home and shot himself through the heart.

At the time of the Queen Square riot there were no police forces as we know them today, only Watchmen known in Bristol as Charleys, who had the right to detain offenders and haul them before the magistrates. Some of their prisons still survive. At No. 45 Picton Street there is a Charley Box with two cells, and dug into the side of Westbury Hill is a windowless lockup, eight feet square. The most unusual lockup I found is the cellar of the Angel pub in Long Ashton, where justices once tried miscreants in the oak-beamed bar. Up to the early nineteenth century this was not unusual, what makes the Angel unique is that the cellar beneath has individual cell spaces hewn out of the rock where offenders were kept, in complete darkness, to await justice. These impromptu prisons were abandoned when Bristol became one of the first British cities to set up its own police force in 1836, following the example of the Metropolitan police force, established in 1829 by Sir Robert Peel (1788–1850) after whom officers were nicknamed 'bobbies'. The officers' uniform was a top hat, blue swallow-tailed coat, white trousers and a cape. They carried a rattle for summoning help as well as a wooden truncheon, with nearby access to a cutlass. Two of the original four police stations survive. One is the former Italian restaurant in Bedminster, which has flats above, while the old Brandon Hill station on

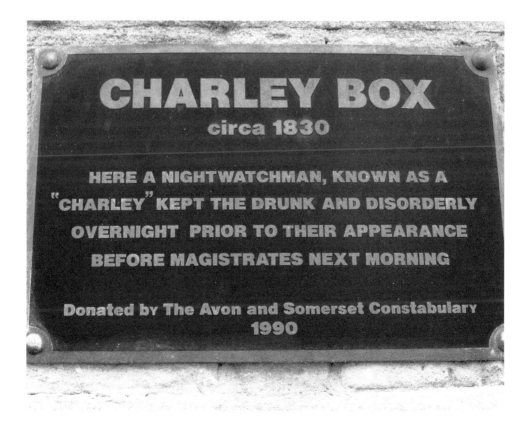

Charley Box plaque.

Charley Box cell.

Lockup, Westbury Hill.

The Angel, Long Ashton.

Angel lockup entrance.

Bedminster's old police station.

Cell window at Avon Wildlife Trust.

Jacobs Wells Road is now the offices of the Avon Wildlife Trust. The cells, steel gates and window-bars there remain intact.

The evening of Wednesday 2 April 1980 found me trundling back from London in my draughty old former Post Office van. It had no radio, so the first clue I had that anything was amiss in Bristol was when I saw policemen standing about on the Easton side of the M32 roundabout, where they had bravely headed when they found themselves in the midst of a riot of their own making in St Paul's. It was not their afternoon raid on a notorious drugs den, the Black & White café, which had upset the local community but their triumphant display of military-style force afterwards, in what was essentially a black ghetto. I passed my local Lloyds bank and adjacent post office, blazing like buildings in the Blitz, and saw police patrol vehicles burnt out and abandoned. Turning into my street, I was surrounded by a mass of angry youths and forced to a halt. As some hammered on my windows, others rocked my little van from side to side, but as I struggled to get out one man separated himself from the crowd and shouted, 'Leave dis guy, him aaall right, he's lived here yurs an' yurs!' As I entered my house, an imaginary headline floated into my head: LOCAL AUTHOR MAKES GOOD.

8. Workhouses, Orphanages, Asylums

'The poor are always with us,' so the saying goes. The King William pub in Bristol's historic King Street was built as a refuge for women paupers in 1652, and near what is now Castle Green there once stood St Peter's Hospital. In 1695 that exceptional West Countryman, Dr Thomas Dover, the Quicksilver Doctor, became the first physician to offer his services free to its destitute patients, and four years later St Peter's became the first workhouse outside London. A survey in 1797 stated that, 'On account of the number of old and diseased persons in it, the house is infested with vermin, particularly bugs.' Just the same, the care these places offered was probably more humane than the system brought in after the Poor Law Amendment Act in 1834. The aim of this Act was to reduce the cost of looking after poor people by stopping relief money being paid to them, so that if they wanted help they had to go into a workhouse to get it. Workhouses offered lodging and just enough food to keep inmates alive, in exchange for work. Their lives were unremittingly bleak. The sexes were separated on entry, even siblings and old married couples, and the daily routine was mind numbingly awful. Rising at 5.00 a.m., from 6.00 a.m. until 7.00 a.m. they had prayers followed by a breakfast of 'water gruel', and from 7.00 a.m. until noon it was work. For women this consisted of scrubbing

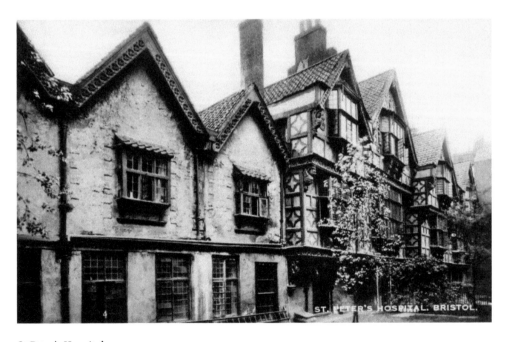

St Peter's Hospital.

stone floors or picking apart tarred rope known as oakum, while the men might drive a treadwheel to grind corn. Dinner was vegetable broth, then it was back to work until 6.00 p.m. More prayers followed before three ounces of cheese for supper at 7.00 p.m., and bed at 8.00 p.m. There were blankets but no sheets or pillows, inmates were usually two to a bed, heating was inadequate and there was no entertainment of any kind. As a treat on Sundays, dinner might be soup made from a bullock's head.

Besides St Peter's Hospital, other workhouses were dotted around Bristol including in Clifton and Southmead, some of whose buildings remain as parts of the hospital. Take a stroll across Rosemary Green in Eastville and you are tramping on the corpses of wretches who died in the workhouse at No. 100 Fishponds Road, unceremoniously dumped there in unmarked graves. The Eastville workhouse opened in 1847 and fatalities were high, it is estimated that over 3,000 lie under Rosemary Green. Many were children, including Mary Larkham, one year old when she died in February 1856, as were Isabella Payne and Ellen Palmer, who died the previous month. In April, Mary Ann Palmer, probably the sister of baby Ellen, died at the age of four. Sixty-five inmates died in that year alone. The workhouse building was only demolished in 1972.

Housing the mentally ill in workhouses was commonplace, and not all facilities were run as the Act had ordered. In 1835, Assistant Poor Law Commissioner Charles Mott reported on the St Philip's workhouse in Pennywell Road, saying:

The state of the workhouse was filthy in the extreme, the appearance of the inmates dirty and wretched. There was no classification whatever, men, women, and children being promiscuously huddled together. In one corner of the building I discovered a most dismal filthy looking room, which presented such a sombre wretched appearance that curiosity prompted me to explore it. I entered, and the scene I witnessed in it is impossible to forget. The room reminded me of a coal cellar rather than the residence of a human being. The sole tenant of this miserable abode was a poor distressed lunatic. His appearance was pitiable in the extreme; his clothing was ragged; his flesh literally as dirty as the floor; his head and face were much bruised, apparently from repeated falls. Shoes he had but his feet protruded through them. He sat listless and alone, without any human being to attend upon or to take care of him, staring vacantly around, insensible even to the calls of nature, and apparently unmindful of anything which was passing in the room. He was endeavouring to avail himself of the only comfort allowed him from the few embers which were yet burning in the grate, for he had thrust his arms through an iron grating which was placed before the fire, intended doubtless to prevent

DID YOU KNOW THAT…?

Muller Road was named after a German immigrant, George Müller, who saved thousands of Bristol orphans from living – or dying – on the streets of Bristol. His orphan houses survive as parts of the City of Bristol College's Ashley Down Centre.

the poor creature from burning himself; but as it was, his hands just reached the embers. I endeavoured to arouse this poor pitiable fellow-creature, but the attempt was useless, all sensibility had forsaken him. To the very great shame of the parish officers, I found he had been in this disgusting state for years.

In 1856, when Eliza Canningford obtained a knife in the Female Imbecile Ward of the Clifton workhouse and cut her throat in a lavatory, no inquest was called for.

When cholera struck in 1832, St Peter's Hospital workhouse held 600 paupers, including fifty-eight girls sleeping in only ten beds and seventy boys sleeping in eighteen. As the infection spread, burial grounds became so overcrowded that corpses were interred on waste ground near the Cattle Market. A parish workhouse in the outlying village of Stapleton had been built in 1779. Originally a prison for captives from the colonial war with America, it later became known as the Old French Prison after French prisoners were incarcerated there. This was developed to hold more inmates, and when cholera struck again in 1849, Stapleton workhouse was badly affected. Nobody knew it was spread through sewage in drinking water and a young surgeon, Dr Joseph Williams, who stayed at the institution to care for victims, caught the illness and died. It was believed at the time that a mother pelican would peck itself until it bled, feeding the blood to its young, and his grave in Arnos Grove cemetery shows the bird as a tribute to him.

In 1861, the Bristol Lunatic Asylum opened within the workhouse, and despite the brutality if its name it was progressive for its time. Stone for the complex of buildings was excavated from a quarry on site, and with Stapleton then a rural area, the asylum had its own farm, orchards, laundry and workshops. Some buildings remain as parts of Glenside Hospital and the adjacent University of the West of England, and the asylum chapel is one of them. A Grade II-listed building, it holds one of Bristol's lesser known treasures, the Glenside Hospital Museum. This contains disturbing exhibits like straitjackets and a padded cell, which it is an eerie experience to enter, and I was taken up a hidden staircase to the room where the asylum Superintendent sat with his family during chapel services, and could spy on his captive congregation through a concealed aperture. In the 1950s an artist, Denis Reed (1917–1979) spent time in Glenside as a patient. While he was there he did a number of moving drawings which are invaluable as a historical record, since photography was never allowed inside the hospital. Glenside Hospital Museum opens on Wednesdays and Saturdays from 10.00 a.m. until 12.30 p.m. It relies entirely on donations, so don't be stingy and drop something in the box.

The story of orphanages in Bristol is the story of George Müller (1805–1898). Born in the Prussian village of Kroppenstedt, Müller was not only selfish as a child, he was criminal, stealing money from his father who was a tax collector. Though only fourteen, when George's mother died in 1819 he was at a tavern, gambling and boozing, he spent most of the next day drinking and did not hear the news until later. At sixteen he was imprisoned for not paying hotel bills, and spent five weeks in a cell before getting up the courage to ask his long-suffering father to bail him out. When his father encouraged him to go to Halle University he agreed and signed up for Theology, not because of any religious conviction but because it could lead to a comfortable, well-paid career as a clergyman.

Right: Glenside Museum straitjacket.

Below: The padded cell at Glenside Hospital.

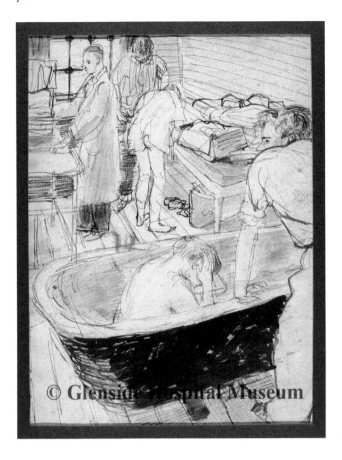

A Denis Reed painting.

While he was there some friends decided to visit Switzerland and asked him to organise the trip, which he did, cheating them over prices to make money for himself.

One night there his friend Beta took him to a house where there was a Bible reading going on. Suddenly, it was as though scales had lifted from his eyes. 'All our former pleasures are as nothing in comparison to this,' he said, and became a Christian. Back home, he decided to become a missionary, which angered his father who saw it as throwing away a good living. George refused his parent's money after that, made a precarious living teaching English and lived rent-free in an orphanage, which influenced his later life. At twenty-four, he graduated and travelled to London to work for the Society for Promoting Christianity Amongst the Jews, but he was taken ill and went to Teignmouth in Devon to convalesce, eventually becoming a pastor there. He married Mary Groves in October 1830, and later that month renounced his salary as it was gained from renting out pews which favoured the rich. In the same year, he moved to Bristol and took charge of a chapel there, besides founding the Scriptural Knowledge Institution which continues to this day, sending an average of £105,000 around the world each month to spread Christianity and help people in need.

By the time he arrived in Bristol, Müller had developed the belief that he would never need to ask for anything, as God would always provide. Moved by the large number

"WE ARE SEVEN" NO 2 N.O.H. 5.

Müller babies.

of orphans living on the streets by thieving or begging as the result of recent cholera epidemics, in 1835 he called a meeting to announce the setting up of a home for them, and confident in his faith, prayed for £1,000 to finance it. The Müllers were living in Wilson Street in St Paul's, close to the house where the world's first woman doctor, Elizabeth Blackwell, had lived until 1831. They opened their doors to thirty impoverished girls, rented No. 1 soon afterwards and filled it with infants, and later added a third house in the street, then a fourth. More children begged to stay with them, and in 1845 there were complaints from the neighbours. George decided the time had come to move, prayed for help, and somehow raised enough money to buy land on Ashley Down, then a rural area outside the city, which he bought for below the asking price. He never borrowed or went into debt, the architect he hired decided to work for nothing, and in 1849 the first home opened its doors to 300 children. Each child had a number sewn into their clothing, they slept in separate dormitories, the girls two to a bed in a huge, seventy-bed room, boys in their own bed in a forty-bed dormitory. Infants were in a room with forty primrose yellow iron cots, looked after by older girls. With more children waiting for a place in Ashley Down, in 1851 George Müller decided to expand, but did not begin until he had the money to finish the project. No. 2 was finished in 1857. As children were often sick, sometimes mortally so, when they arrived at the orphanage each house had an infirmary. There were some deaths but a good diet, fresh air and exercise ensured that the children were generally healthy. Mealtimes and other activities were marked by the ringing of the bell in the clock tower of No. 1 House, and domestic work was done by the children as part of their training for later life. By 1868 there were four houses caring for 1,600 orphans.

74

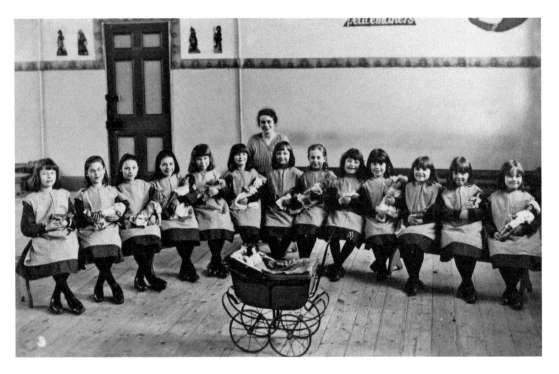

Girls.

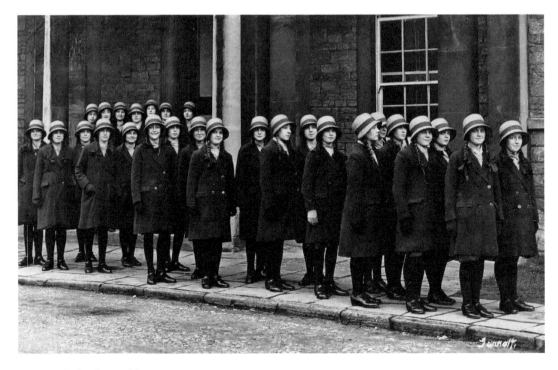

Ready for the world.

A fifth house followed. The children received a good general education, and in addition the girls did domestic duties while the boys learned skills that readied them for the world of work. In marked contrast to what often happens today, with care leavers ending up on the streets or in prison, the Ashley Down children were all found jobs before they left the institution. When Müller died in 1898 at the age of ninety-two, shops and factories throughout Bristol closed for the day and thousands took to the streets to pay him homage.

There is a Muller Museum at No. 7 Cothan Park, BS66DA, visits by appointment only.

9. War!

The First World War

The First World War, hailed as 'the war to end war', broke out in July 1914, and when Germany invaded Belgium the following month it was declared to be fought 'for the Rights of Small Nations.' In the beginning, not everyone was in favour of the war. Bristol's trade unionists opposed it, saying that British workers had more in common with their German counterparts than they did with employers, but by waging a vigorous propaganda campaign that involved everything from love of home and family to God, the government whipped up a war frenzy that was as fervent as it was misguided. One hard truth for modern feminists to accept is that Bristol's Suffragettes, drawn mainly from the middle classes, shelved their demand of Votes for Women and began handing out white feathers, a token of cowardice, to men not in uniform. Around 60,000 Bristol men joined up, of whom 7,000 were killed. By January 1915 a million men had enlisted nationwide. When this did not keep up with the casualties, in 1916 conscription was introduced for all single men and the army grew by two and a half million. The upper age limit for conscripts was forty-one, later raised to fifty-one. During the worst fighting on the Western Front junior officers had a life expectancy of only six weeks, so that the proportion of fatalities among

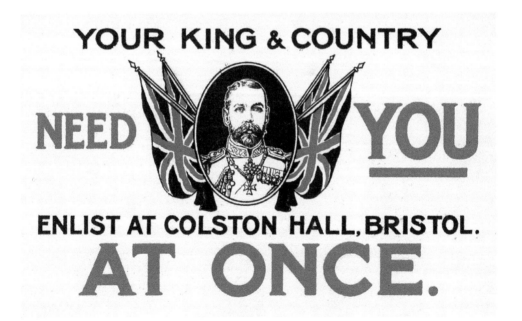

Call to Arms.

St. George, Brandon Hill.
At our Easter Communion we are praying for them.
May the Risen Christ, Who left His Home for us, have them in His keeping
GEORGE W. PITT, Vicar
P.T.O.

God on our side.

Old Boys of Clifton College was higher than that in the general population. Out of 3,000 who joined up, 580 died.

The most famous Old Cliftonian was Douglas Haig (1861–1928), heir to the Scotch whisky business empire and a veteran of the Boer War. In a conflict that was said to be 'fought by lions led by donkeys', he was the chief donkey. He believed that trench warfare should be finished with a cavalry charge, and that the machine gun was 'a much overrated weapon.' In 1915, he stated: 'The way to capture machine guns is by grit and determination.' Planning the disastrous Somme campaign in 1916, he said glibly, 'The nation must be taught to bear losses,' and sent thousands of men to a pointless and unnecessary death. Out of 58,000 casualties on the first day, a third were killed, and this remains a shameful world record. The battle was called off five months later with little gain, earning Haig the soubriquet, Butcher of the Somme.

As well as boots and motorcycles made in Kingswood, Bristol's industries provided comfort for the soldiery in the form of Fry's chocolate and Wills' cigarettes. As described in Michael Morpurgo's modern classic, *War Horse*, at the start of the First World War horses were the main means of transport. The first army force sent to France in 1914 went through 165,000 in just the first three months, and of the half million later imported from the USA and Canada through Avonmouth docks, 350,000 passed through the Remount Depot in Shirehampton, then a village surrounded by open fields, to be rested and made

fit after their long sea journey before being sent to their deaths. Bristol's influence on transport extended far beyond horses. Around half of the pilots of the fledgling Royal Flying Corps were trained at George White's Bristol flying schools, and his decision to place one at Larkhill on Salisbury Plain, the army's main training area, was particularly farsighted. Boxkites were adapted for military use and the faster Bristol Scout was also ordered by the Royal Flying Corps, forerunner of the RAF. The first aircraft ever to take off from the deck of a carrier was a Bristol Scout of the Royal Navy Air Service, while the F2 B Bristol fighter, made at the Tramways works in Brislington as well as at Filton, turned the air war in favour of the Allies in 1917.

A new element in Bristol's wartime industries was the predominance of women, as nurses, 'clippies' and even drivers on the trams, or doing dangerous work in munitions factories. Bristol's seamen also played a leading role in the First World War. When the passenger liner King Edward, converted to a troopship for the Dardanelles Campaign against Germany's ally Turkey, was torpedoed in August 1915 most of her troops and her Bristolian crew were below decks and over 1,000 drowned, 132 of them from Bristol. Before this disastrous campaign was finally abandoned, thousands of Allied men, including your author's grandfather, were mown down by machine-gun fire as they landed at Gallipoli.

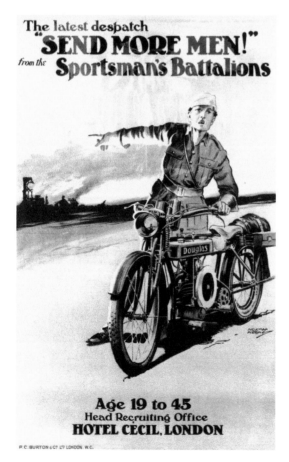

Douglas poster.

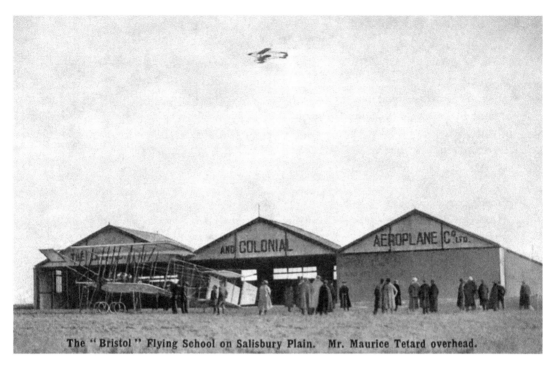

The "Bristol" Flying School on Salisbury Plain. Mr. Maurice Tetard overhead.

Boxkite school.

An early tank.

DID YOU KNOW THAT...?

In 1916 Britain exported new, top secret fighting machines through Avonmouth. Afraid they would be spotted by enemy aircraft on their train journey to the Front, the army passed them off as fuel tanks, and misled the Germans by shrouding them in canvas marked with the word by which they are still known: TANKS.

As casualties mounted, the role of hospitals became vital and the BRI was pressed into service from 1914, soon to be followed by the recently opened Workhouse Infirmary at Southmead. The first trainloads of wounded were cheered by Bristolians but the authorities, knowing that the sight of horribly maimed men would undermine morale, brought later trains in during the hours of darkness. Antibiotics did not yet exist, yet the Bristol hospitals did a wonderful job in saving lives. In a bid to ease demand, the Glenside Lunatic Asylum became the Beaufort War Hospital, and some asylum inmates were retained to work there. The ground-breaking painter Stanley Spencer (1891–1959) was a medical orderly at the hospital and said they were good workers, adding, 'One persists in saluting us and always uses the wrong hand. Another thinks he is an electric battery.' Spencer recalled his days at the hospital in series of frescoes at the Sandham Memorial chapel in Hampshire.

Wounded arriving at Beaufort Hospital.

That most cruel and horrifying weapon, mustard gas, was made in Avonmouth from January 1918 and loaded into explosive shells at nearby Chittening. Nobody had experience of handling such deadly toxic material, leaky valves and tanks allowed gas to escape, and with the Department of Munitions demanding that hundreds of tons of gas be packed into shells by autumn, accidents happened on a terrifying scale. Around fifty people were taken to the factory hospital every day with blisters, respiratory or eye problems, four died, and three-quarters of the 1,100 workforce were affected. Mustard gas was not used until the last months of the war but workers were left with lasting injuries and many had their lives shortened.

Despite exhortations to patriotism, there were unofficial strikes throughout the war at the Douglas motorcycle plant, the boot factories of Kingswood and Bristol's aircraft factories. Hundreds of tramways workers went on strike when some were sacked for joining a union, and their employer eventually capitulated. Even during the war, the Rights of Small Nations were ignored when they were demanded closer to home. The Easter Rising in Dublin was put down harshly, with weekly hangings that proved counterproductive when they triggered the IRA guerrilla campaign that led to Irish independence. The First World War ended at 11.00 a.m. on 11 November 1918, the hour of the eleventh day of the eleventh month, and Remembrance Day is celebrated on the Sunday closest to that date.

When the Remount Depot in Shirehampton closed in 1919, the troops' billets were given over to council housing.

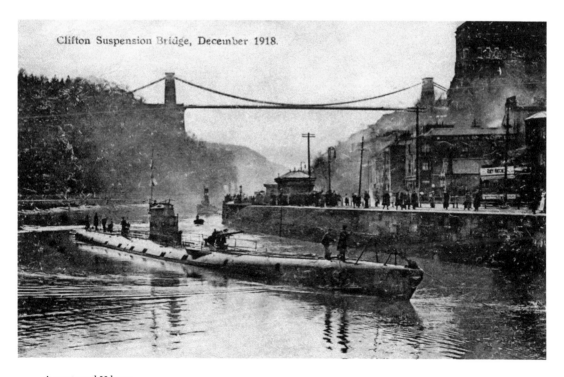

Clifton Suspension Bridge, December 1918.

A captured U-boat.

Second World War

When Germany invaded our ally Poland in September 1939, Britain declared war. The knowledge that enemy aircraft would be able to reach anywhere precipitated the distribution of 3.5 million home-assembly air raid shelters, made of corrugated iron and named for the man in charge of air raid precautions, Sir John Anderson (1882–1958). Anderson shelters can still be seen in Bristol. First World War memories of poison gas, fresh in the national consciousness, caused gasmasks to be issued to all, even babies, and city children were evacuated to the countryside. The conflict was soon nicknamed the Phoney War because at first nothing much happened, and that was just as well because it gave the authorities time to organise defence. Bristol's status as the home of the Bristol Aircraft Company and the biggest port in the South West made it a prime target for the German air force, the Luftwaffe, and as a feasibility exercise a lone bomber attacked the BAC factory at Filton in mid-1940. On 25 September there was a daylight raid on the factory, preceded by diversionary raids on Plymouth and Portsmouth to mislead the RAF. Fifty-eight Heinkel bombers with an escort of forty Messerschmidt 110 fighters attacked BAC, landing a direct hit on two air raid shelters which, stupidly, had been placed together. The life of Roy Mockridge, a sixteen-year-old apprentice, was saved because he had brought a crime novel, disapproved of by his mother, to work. He was sitting by the door to read it when an air raid warden, who had seen the stick of bombs fall from a Heinkel, ran in shouting, 'Get down!' All the people in the middle of the shelter where Roy usually sat were among the more than 200 killed.

Anti-aircraft fire shot down eight enemy aircraft that day but forty-eight hours later ninety more planes attacked Bristol, and were driven off by the RAF. Worse raids followed. On 2 November 5000 incendiaries and 10,000 high explosive (HE) bombs rained down on the city, killing over 200 and injuring 700. These days much is made of the Allied bombing of the historic German city of Dresden, but the destruction on Sunday 24 November 1940 of the densely packed, largely intact medieval area around what is now Castle Park, then Bristol's main shopping centre, is seldom mentioned outside the city and little known within it. This may be because Coventry had been bombed ten days earlier and the government, fearful that morale would be damaged if the truth were reported, merely stated that 'bombs fell on a town in the west.' The Luftwaffe, aiming for the city docks and the freight yards at Temple Meads but failing to eliminate either, arrived at 6.00 p.m. They lit their way with parachute flares before 148 aircraft unloaded 12,500 incendiaries and 156 tons of HE, many onto the central area of the city, reducing picturesque Old Bristol to rubble, and destroying the generating centre for Bristol's trams. As well as 10,000 homes and eight schools being damaged or destroyed, the city's best known landmark, the timbered Dutch House built in 1676 on the corner of Wine and High Streets, was devastated. St Peter's Hospital, the timber-framed Tudor house that had been the city mint and later a workhouse, was still in use as a register office. It was destroyed that night, along with seven modern churches and four ancient ones. Little remains now of St Mary-le-Port, the sailors' church where John Cabot would have been blessed before setting out upon his historic voyages, and of St Peter's on Castle green there remains only the shell. Temple church, whose tower still leans as it has done since 1390, is a similar ruin while St Nicholas took incendiaries through its roof that destroyed the interior, and has never been used as a church since.

Right: Old Dutch House.

Below: End of the line for Bristol's trams.

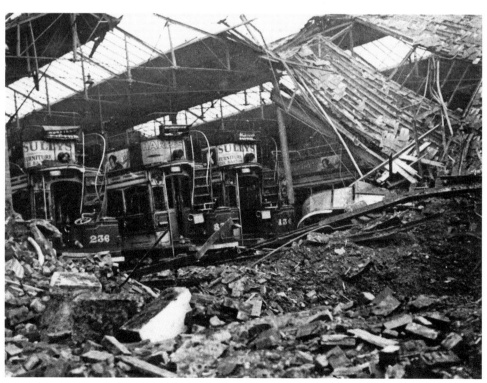

The casualty toll for the 24 November raid was 200 dead and 689 injured, fewer than first feared because it happened on a Sunday when the central area was less populated. Houses in Bedminster were flattened on that dreadful night and over half the shops in Park Street were damaged or destroyed. They were rebuilt in the 1950s, when the city architect had the good sense to ensure that the replacement work was carried out in a similar style. Alas, this was not the case elsewhere, with historic buildings needlessly demolished and the River Frome, running through the centre, covered now in featureless concrete.

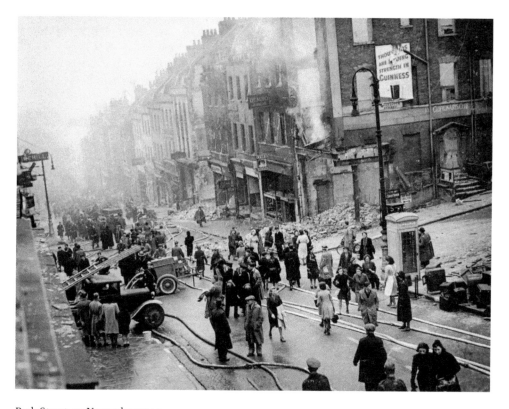

Park Street, 25 November 1940.

10. Hidden Places, Famous Faces

Turn left up any of the roads off Park Street before the Clifton triangle, then follow your nose onto Brandon Hill. In summertime bring peanuts, as the beautiful parkland is home to the tamest of squirrels. At the hill's peak stands Cabot Tower, built in 1897 to commemorate the 400th anniversary of John Cabot's epic voyage. The Bristol tower is Grade II listed, stands 32 m (105 feet) high and flashes out the word 'Bristol' in Morse code during the hours of darkness. Entry is free and although the spiral staircase is tortuous, the amazing views when you reach the top make every step worthwhile.

Cabot Tower.

DID YOU KNOW THAT...?

When Cabot Tower was opened on the 400th anniversary of the explorer's epic voyage in 1897, another Cabot Tower was opened in Newfoundland. This tower made history in 1901 when Marconi used it to receive the world's first transatlantic radio signal.

Retracing your steps and turning left along the triangle will bring you past QEH, the Queen Elizabeth's Hospital independent school which has been going since John Cabot was a lad. Keep left past the QEH theatre, and at the bottom of Jacob's Wells Road you will pass the old Brandon Hill police station, now the headquarters of the Avon Wildlife Trust. If you are in need of refreshment, the Bag o' Nails pub is interesting, but cross to St Peter's House, the block of high-rise flats opposite, and you will see a square archway that you would normally pass without a second glance. Go through it, and you walk into the past. White Hart Steps were named for a long ago pub whose legacy is a leafy escape from the bustle of the city, with side-shoots like World's End Lane and a secret garden near the summit. The gates of the old cottages remain firmly shut, but who can blame the residents for wanting privacy? It must have been a shock when they learned that their view of the boats at Baltic Wharf would be shut off by a cliff face of council flats. Turn right at the top of the steps and you will reach Goldney Hall, a classic eighteenth-century pile with an orangery and a tower in its elegant gardens. If entry seems daunting just carry on to Constitution Hill on your right, one of the steepest in hilly Bristol, where a black gate in the wall gives public access.

In the M Shed museum there is a photograph of a Victorian urinal in Bedminster, long ago demolished but with a fragment of its filigree ironwork on display. There is nothing wrong with that but an identical structure, reminiscent of a Parisian pissoir, stands on Horfield Common looking forlorn and neglected, its entrance permanently locked. Do we have to wait until it falls apart before it can be appreciated? If enlightened Victorians could build and maintain such conveniences and keep them open, how is it that twenty-first century Bristol cannot? Nearby in Horfield the Hollywood legend, Cary Grant, was born as Archibald Leach and grew up in terrible poverty. At the age of nine, his alcoholic father told him that his mother had died, though in reality he had had her committed to a mental institution. At fourteen, young Archie walked out of Fairfield Grammar School in Montpelier to join a travelling juggling troupe, and when they performed in New York two years later he struck out on his own. In a career spanning thirty years, he made films with another English Hollywood great, Alfred Hitchcock, and reached the pinnacle of success. Cary Grant never forgot his roots and he visited Bristol often. A bronze statue of him stands in Millennium Square.

Even if you have noticed the Doulton tiles covering Edward Everard's Palace, the beautiful art nouveaux former printing works in Broad Street, the chances are that you have never ventured down nearby Tailors Court. At its far end on the right there is a rare

Urinal in Horfield.

and complete Jacobean town dwelling, Court House, which would make a fantastic hotel or conference venue. It is in a prime area for such a venture, yet it stands abandoned to the elements in a way that is little short of criminal. Above its entrance, Court House has the first example of a shell hood in Bristol, while across the road, over the doorway of the former guildhall of the Merchant Taylors which gave this little street its name, there is another that looks even more impressive. Established through royal charter by Richard II in 1399, the guild built the hall, probably on the site of an older one, in 1740.

The Redcliffe area abounds in curiosities that can easily be overlooked. Opposite St Mary's Church at the bottom of Redcliffe Hill stands the Quakers' Burial Ground, once called the Redcliff Pit. It was donated to the people of Bristol by the Society of Friends, or Quakers, in 1950 and is now a small park that provides a city refuge. The Quakers bought the land in 1665, five years before they began meeting at Quakers' Friars, and at its far end, strangely, there is a cave once inhabited by a hermit. The hermitage was established in 1346 by Lord Berkeley, whose manor house was in nearby Bedminster, and a man called John Sparkes was installed there to pray for the Berkeley family. In all, the hermitage was used for over three centuries. Quakers figure prominently in Bristol's history. How they managed to reconcile it with their beliefs is anyone's guess, but they were involved in the slave trade at its outset. At least two, Charles and John Scandrett, owned slave ships while others, like the Fry's chocolate firm, thrived on the trade's imports. Once they had

Hermit's cave.

considered the implications in terms of human suffering, though, Quakers were among the first to demand abolition.

St Mary Redcliffe church is crammed with oddities, like the whalebone brought back by John Cabot, the two tombs of William Canynges (1399–1474) and the armour and replica battle pennants of Sir William Penn (1621–1670) whose son founded the American state of Pennsylvania. Above the north porch lies the Chatterton Room, called after the Bristol poet Thomas Chatterton (1752–1770) – yes, those dates are correct, he died before his eighteenth birthday. It was in the room now named for him that as a young boy, Thomas, who began publishing poems at the age of eleven, found ancient parchments relating to the estate of William Canynges. These fascinated him, and he was able to mimic their Middle English so well in his beautiful verse that he passed them off as authentic thirteenth-century works, attributing them to a fifteenth-century priest of his own creation, Thomas Rowley. Like a modern criminal carrying out identity theft, Chatterton took the name from a tomb in St John-on-the-Wall church, whose brasses can still be seen. When this ruse did not bring him recognition, Thomas fled to London determined to live by his pen, but died soon afterwards by drinking arsenic and opium given to him to treat gonorrhoea. A hasty inquest brought in a verdict of suicide and for over two centuries scholars accepted this, but there are fashions among historians as elsewhere and many modern academicians now believe that Thomas's death was the

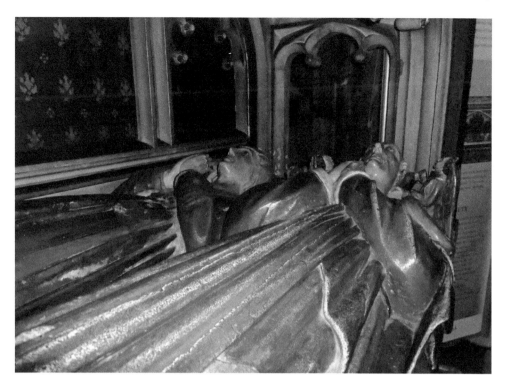

William Canynges' first tomb.

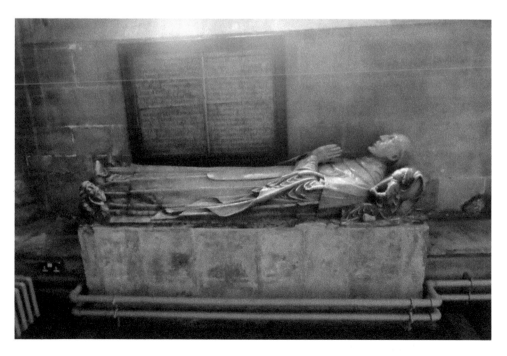

Canynges' second tomb.

Left: The Rowley brasses.

Below: Chatterton House.

result of an accidental overdose. In the final analysis, though, his death happened in a locked room more than 250 years ago, so mystery will always surround the Marvellous Boy, as William Wordsworth called him. Chatterton was influential in the work of the Romantic Movement that followed him, and his birthplace survives opposite St Mary's on Redcliffe Way, with plans afoot to open it as a themed café.

Rules against outsiders trading within Bristol's city walls were strongly enforced in the 1500s, and when an intrepid group of Chinamen took up residence to the south of St Mary Redcliffe church due to this prohibition, the area became known as Cathay, the old name for China. There is still a Cathay Street there, and high on the wall of number nine Colston Parade there is a plaque commemorating the birthplace of Samuel Plimsoll (1824–1898). Considering our maritime past, it is strange that this son of Bristol should be so neglected. He battled for the welfare of seamen and saved the lives of countless sailors by devising the Plimsoll Line, which is now used on all seagoing ships worldwide to mark the point beyond which it is unsafe to load them. Before its introduction, unscrupulous owners thought nothing of over-insuring ships and sending them to sea overloaded, because they knew that if the vessel sank they would be assured of a handsome profit. Although there has been a statue to him on London's Victoria Embankment since 1929, a Bristol statue gathered dust in storage at the City Museum until 2010 when it was unveiled close to the SS *Great Britain*. A little further along Colston Parade stands Fry's House of Mercy, opened for destitute widows in 1784 by a Quaker wine merchant, William Fry. The

Tramline at St Mary's, and Fry's House.

house was very poorly endowed, receiving only three shillings a week. Facing it within the railings of St Mary's churchyard, there is a heavy piece of rusted metal embedded in the ground. This is a length of tram track that landed there during the Blitz, when a bomb landed at the corner of Guinea Street, uprooted it from the roadway and flung it over the roofs of houses to land where it is now, like a javelin on a school sports day. The church has left it there as an illustration of the brutality of war.

Continue walking away from Redcliffe Hill, and at the base of the left hand wall in Pump Lane you will see a semicircle of brick that is darker then the stonework above it. This was the top arch of the old Bristol docks railway where it descended beneath the churchyard to smash its way through Redcliffe Caves before emerging beside the Ostrich

Kiln Restaurant

pub on Lower Guinea Street. Theories abound these days about the origin of the Redcliffe Caves network, some saying that they were made as a prison for slaves, others as a haven for smugglers. In fact, they were hollowed out to get sand for the glass industry which flourished here until the 1930s. Only one sign of this remains today in the Kiln Restaurant nearby in Prewett Street.

Besides the many already mentioned in Secret Bristol, here are some famous Bristolians, born or adopted, whom you may know: Lee Evans, Acker Bilk, James May, Derren Brown, Russell Howard, Judd Trump, Gareth Chilcott, Stephen Merchant, Massive Attack, Julie Burchill, W. G. Grace and Johnny Ball.

The number of is too large to be recounted here. Perhaps I should write a book about them?

Bibliography

Dresser, M., *Slavery Obscured*
Dresser, M. & Giles, S., *Bristol & Transatlantic Slavery*
Eagles, John (A. Citizen), *The Bristol Riots*
Powell, Damer *Privateers*
Long John Silver Trust, *The Bristol Treasure Island Trail*

Acknowledgements

I wish to express my gratitude for the help given to me by Dawn Dyer at Bristol Reference Library, Mark Steeds, John Penny, the Bristol Record Office, Bristol Museum, the George Müller Museum, The Baptist Union, Glenside Hospital Museum, and for images, the late Derek Fisher.

Also Available from Amberley Publishing

ANTHONY BEESON

CENTRAL BRISTOL

THROUGH TIME

This fascinating selection of photographs traces some of the many ways in which Central Bristol has changed and developed over the last century.

Paperback
180 illustrations
96 pages
978-1-4456-0825-9

Available now from all good bookshops or to order direct
please call **01453-847-800**
www.amberley-books.com